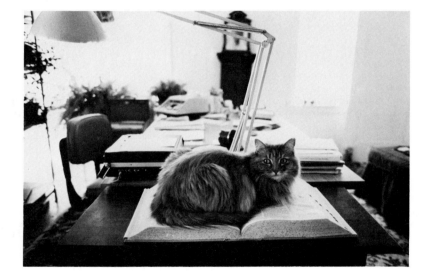

A Studio Book

Categorically Speaking

Photographs by Lynn Lennon

Introduction by Jessamyn West

**The Viking Press
New York**

LYNN LENNON is an artist and free-lance photographer whose work has appeared in the magazines *Art Week, D Magazine,* and *Vision,* and in the book *Self-Portrayal,* published in 1979 by the Friends of Photography. Her photographs have been exhibited in numerous group exhibitions and in one-woman shows at Neikrug Gallery in New York; The Gallery of Photography in Dublin, Ireland; Focus Gallery in San Francisco; Soho Cameraworks Gallery in Los Angeles; and Contemporary Arts Museum in Houston, as well as other galleries and museums. Ms. Lennon has recently completed a photographic series on the sugar plantations of Louisiana that was commissioned by the Louisiana Arts and Science Center. She has also done a study of the people who live in the Big Thicket area of East Texas and a group of fantasy self-portraits inspired by a recurring dream of flying over Dallas in a glass coffin. Lynn Lennon is a native of Texas and a graduate of Baylor University. She lives in Dallas.

First published in 1981 by
The Viking Press (A Studio Book)
625 Madison Avenue, New York, N.Y. 10022
Published simultaneously in Canada by
Penguin Books Canada Limited

Library of Congress Cataloging in Publication Data
Lennon, Lynn.
Categorically speaking.
(A Studio book)
SUMMARY: Ninety-two photographs of cats,
captured by the camera at play, asleep, and in other activities.
1. Cats—Pictorial works. [1. Cats—Pictorial works] I. Title.
SF446.L46 779′.32 80-27231
ISBN 0-670-20685-7

Printed in the United States of America
Set in Baskerville

Introduction

If Androcles, whose life was saved by a lion, had under-taken to write of lions, his account would have differed from that of persons whose association with lions had been less personal.

My account of cats, though I never did for any cat what Androcles did for the lion that spared his life, likewise dif-fers from what it would have been had my cat Samantha and I not shared what was assumed would be my death-bed.

This is not to say that I had been unaware of cats before Samantha's advent. Who could have eyes and fail to see at least a portion of the grace and valor visible even in pho-tographs?

Cats were among the very first animals to be loved and admired by prehistoric men. Early man admired the cat because man was in the process of becoming human. He was beginning to admire what was beautiful as well as what was edible. The cat was invited to share his fireside, while the cow who gave milk and the sheep who provided a pelt, were not. Even the dog, herder and hunting com-panion, could not claim a seat as near the fire as the cat.

This being, who was becoming human, was also devel-oping differing tastes. The human called female found pleasure in arms that could clasp as well as wound; a voice that could purr (a vocalization still not understood) was

more entrancing to her than one able only to bark, roar, or snarl.

The cat has always been regarded as the particular crony of women, at home in their arms, the watchdog of their pantry and cellar. Yet it had qualities especially admired by men.

The cat is very macho. A womanizing man is said to be tomcatting. The cat is independent, brave, promiscuous, athletic, fearless, a hunter. All manly traits. Men think.

Think twice about a man who dislikes cats. He invariably turns out to be a fellow with doubts about his own masculinity. He tries to build up the image of his own virility by voicing disdain for the animal accepted as a pet by women.

I had never, at the time I was sent home from the tuberculosis sanatorium "to die amongst my loved ones," in the doctor's words, had a pet of any kind: dog or cat, canary or horned toad.

I was married, thirty years old, and the home I was returned to was my father and mother's. And when I was transferred to the bed I was expected to die in, there was, poor darling, sentenced to the same bed a kitten of two months. She had arrived in a shoebox, a black and white tabby of no great beauty, but of enormous spirit and affection.

"From the minute that kitten arrived, you began to get well," my doctor told me.

From the minute Samantha arrived, I began to want to get well. That I know.

Tuberculosis is a very lonely disease. Fifty years ago, getting you home to die among your loved ones was about the most therapeutic thing a doctor could do for you. And even your loved ones, because of the infectious nature of the disease, were wary of getting too close.

But not Samantha. No, not Samantha! She slept every night under the covers at the foot of my bed. I do not know how either of us endured that.

She knew nothing about Cat Chow or Tender Vittles. She ate what I ate: creamed spinach, poached eggs, cottage cheese.

At night when I was wakeful, she too was wakeful and played games with me. Out from under the covers she came to play cat and mouse. She was the cat, and I, my fingers twitching under the covers, was the mouse. She sprang at my fingers, then, having destroyed them, she hid, giving another family of mice time to mature.

For some reason she would lower her mouth to mine; the motion was nibbling, but nearer a smack than a snack. Since she could be depended upon to do this, I would say to her, astounding anyone present, "Give me a kiss, Samantha." This she always did, and onlookers applauded my trained cat.

Samantha understood how lonely it was in my upstairs bed: playing with fake mice, receiving fake kisses.

Out of her understanding Samantha carried upstairs to my bed loose objects she found downstairs: a plug, detached from the bathtub; a wilting camellia; a half-cleaned radish.

At the end of a year, Samantha and I were both plumper, our plumpness achieved in different ways. My disease was not cured. That word is not used for tuberculosis. But it did appear to have been arrested; and I had gained twenty pounds.

How much Samantha had gained, I do not know. But she was pregnant, and at least five kittens heavier.

I have never since been without a cat. Samantha's line was carried on by one of her kittens, Brownie. Brownie, as children will, produced a kit that was Grandma Samantha's spit and image.

Three cats lie beside me as I write. Visually, Samantha has not left her mark. But one of the three is a kiss-nibbler. The second eats spinach. Number three sleeps under the covers if she can get there.

If God gave puppies to little boys, He blessed the bedfast with kittens. Puppies entertain, it is true, but kittens cure. I know.

Jessamyn West

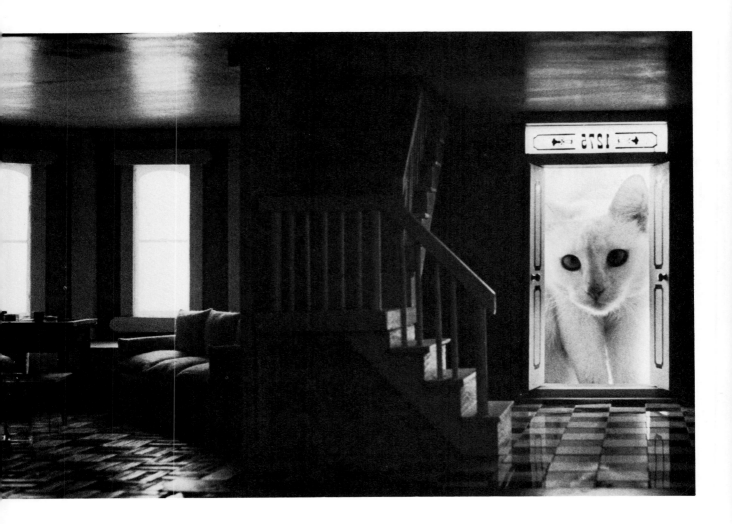

Categorically Speaking

When I began to do this book, I had ten months to take one hundred photographs. Other matters intervened, and six months later I still needed eighty pictures. I began to ask everybody I encountered—including complete strangers—if he or she owned a cat and if I could come and photograph it. Soon I found myself lurking around the supermarket, watching to see who put cat food in a grocery basket.

Once a contact was made, each cat owner, almost without exception, was delighted at the chance to have a beloved pet immortalized in a book. The next problem was explaining the situation to those owners whose pets didn't make the cut. Some begged, pleaded, even insisted that I come again if the first trip hadn't yielded anything worthy. In those last four months I visited well over a hundred cat owners, carrying three cameras equipped with three different lenses up and down alleys, along country lanes, and through city streets. Who would have thought that not one cat could be found around the Fulton Fish Market in New York?

I developed a theory: Interesting people have interesting cats; crazy, bizarre people have crazy, bizarre cats; dull, uninteresting people have the same kind of pets. I acquired a sixth sense. I could walk into a house and tell right away whether it was worthwhile to stay around or better just to snap one or two quick shots and say thank you.

Many a useless frame was clicked away at times when it was obvious that an owner thought his cat was doing something "cute." I wasn't looking for cute, but this was hard to explain. It was easier just to take the picture. The owner would purr "Oh, look!" and if the shutter didn't snap at once, would grow puzzled and suspicious. What did I want if Fluffy peeping out of an oversized bedroom slipper wasn't it? The best of all possible situations was to be left alone with the cat, so that I could sit back and relax and let the cat be itself.

In one house a fierce domestic quarrel raged around me while I tried to go about my business as though I didn't notice. In another home pathetic sobs pulsated through a closed door the entire time I was there. Not by the slightest facial expression did anyone acknowledge these sounds. It was as if I were the only one who could hear them.

One woman's husband became upset when he called and discovered that she had let me in without any real identification. He rushed home from the office and sat in obvious disapproval until I left. Another woman—a total stranger—had to leave unexpectedly as soon as I arrived. Without a second thought she left me in a gorgeous home filled with silver, ivory, and a stunning art collection. She asked me to pull the door to when I left. I don't think she even knew my name.

One woman who had lived in the Far East kept some thirty cats, four dogs, two parrots, and a monkey in an elegant showplace of a home. Another lived with forty-seven cats and seven dogs in a three-room house. There was no

running water, but the place was spotless. She worked at a night job so that she could spend her days taking care of the pets. Everyone knew about her devotion to animals, so strays were constantly being abandoned in her yard. A great deal of her money was spent on having sick and injured animals attended to by the vet.

A man in Austin fed his cats slices of white bread on a piece of newspaper. At the other end of the scale was a woman who told me her Persian would eat only fresh, cooked shrimp. And that's what he got. Every day.

Often I would be introduced to the pets. "This is Veronica, my cat. This is Tiger, my son's cat, and Taffy, Rover's cat." I had no idea that dogs could own cats, but clearly this was the situation.

I crawled under houses and climbed onto roofs. At two a.m. on a cold morning I was called out to the country to photograph the birth of a litter of kittens. I shot pictures by day, developed film and made prints at night. I waited interminably for sleepy, sluggish cats to move and for hyperactive cats to calm down. I was bitten and scratched, nuzzled and loved. I developed an allergy and a rash. I loved it.

Lynn Lennon

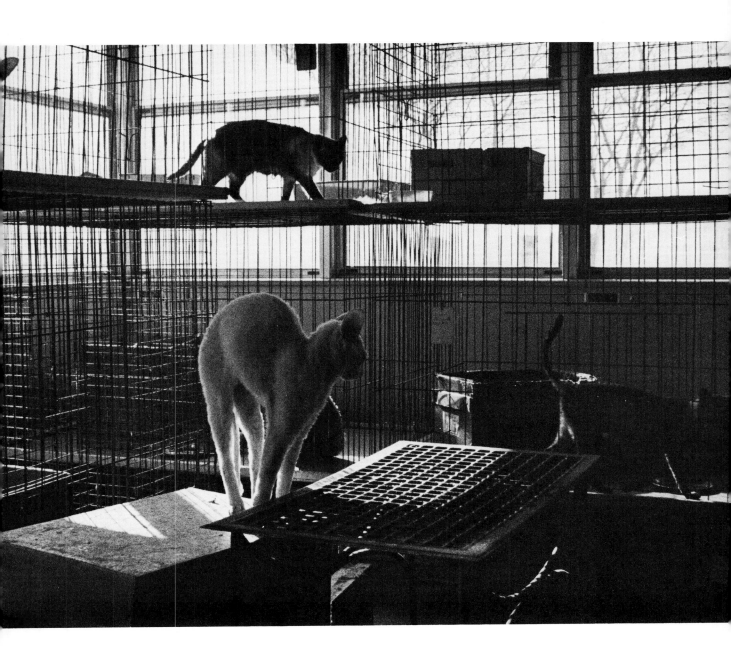

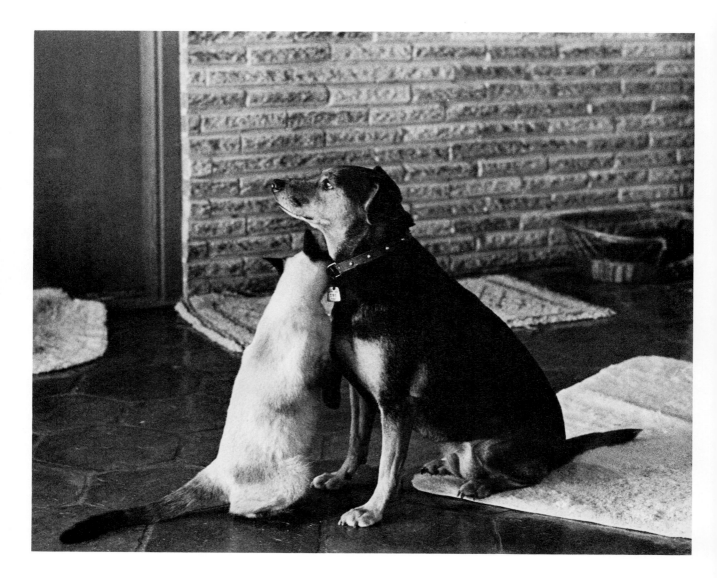

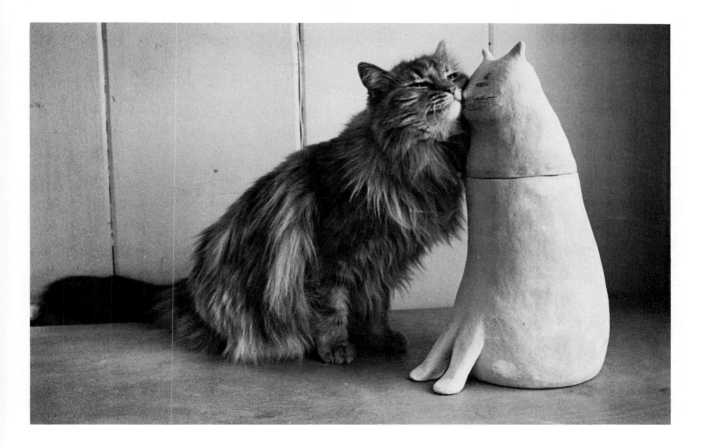

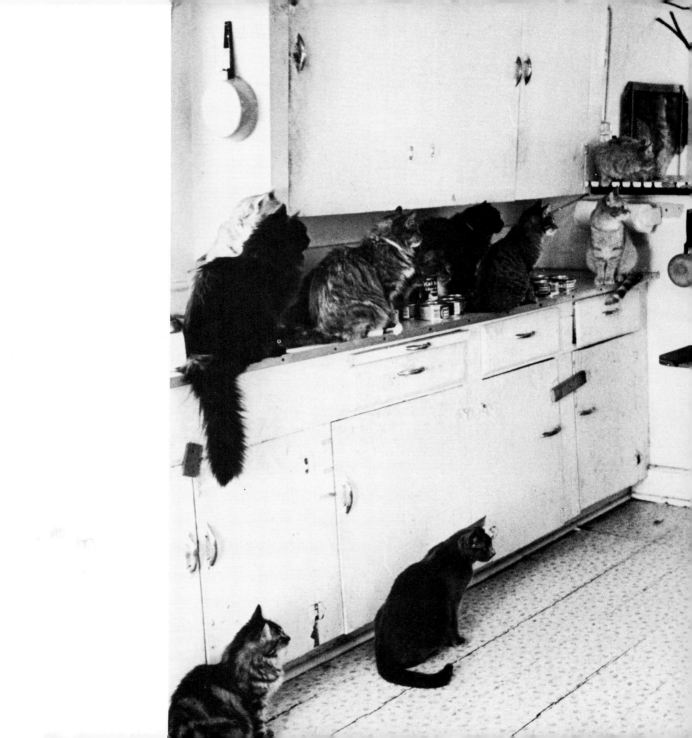

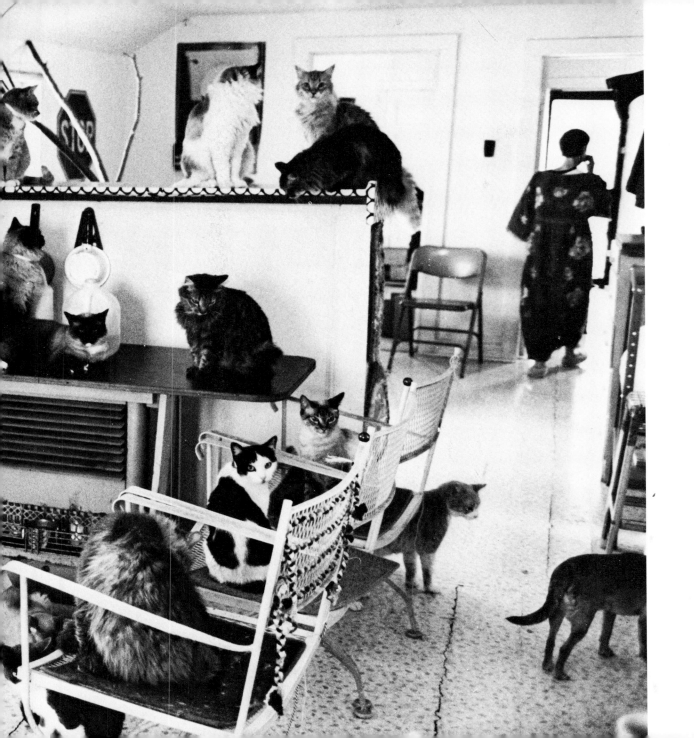

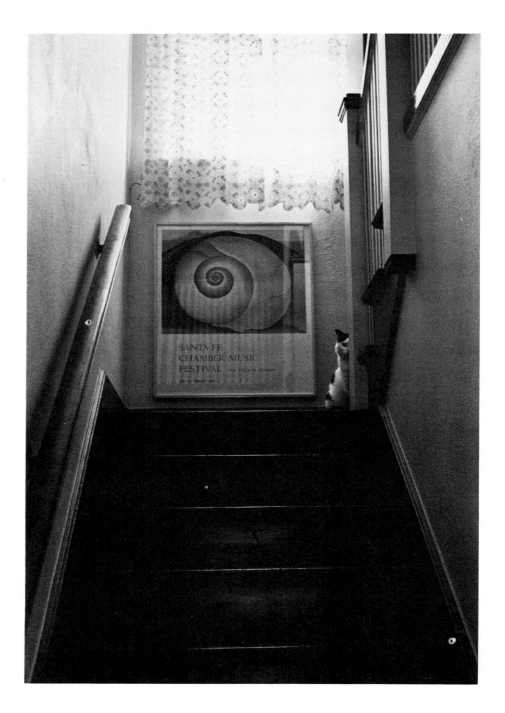

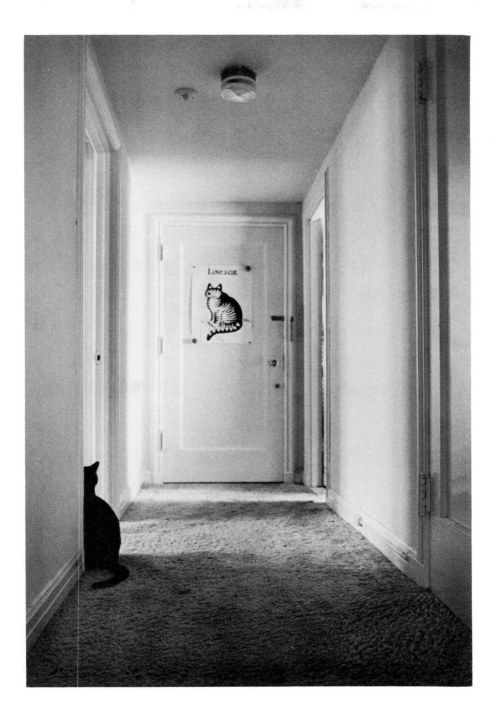

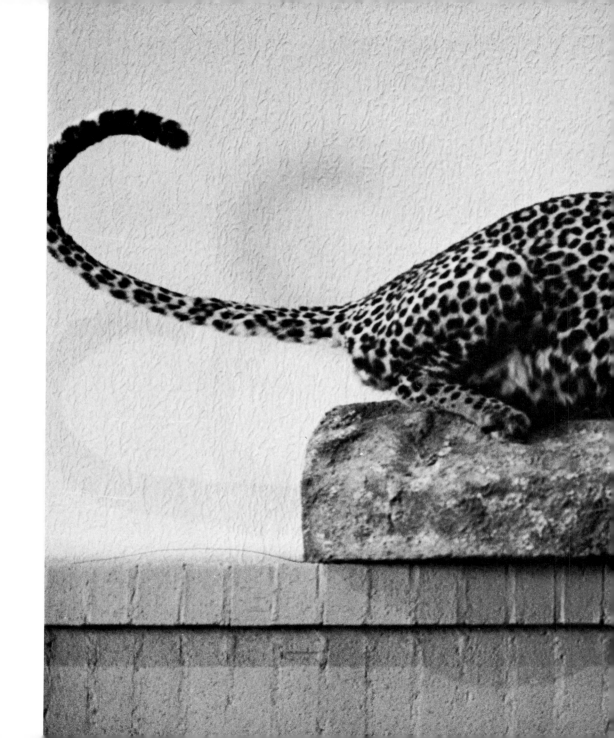

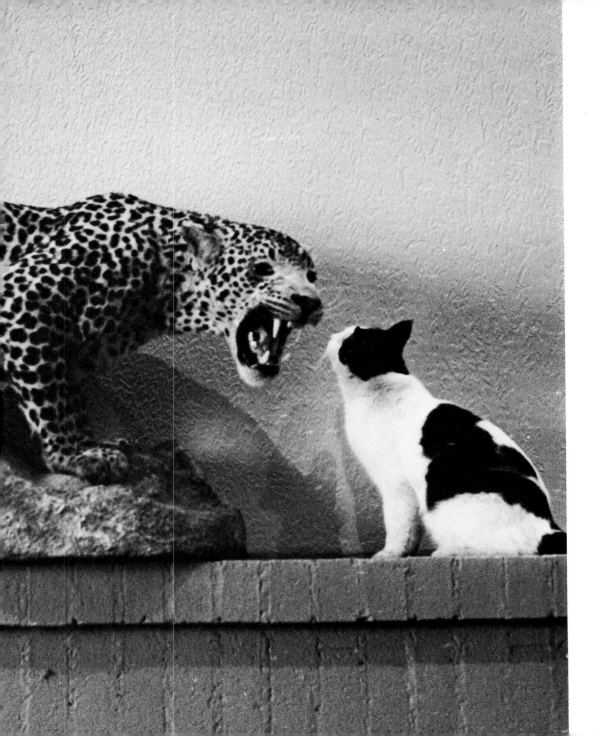

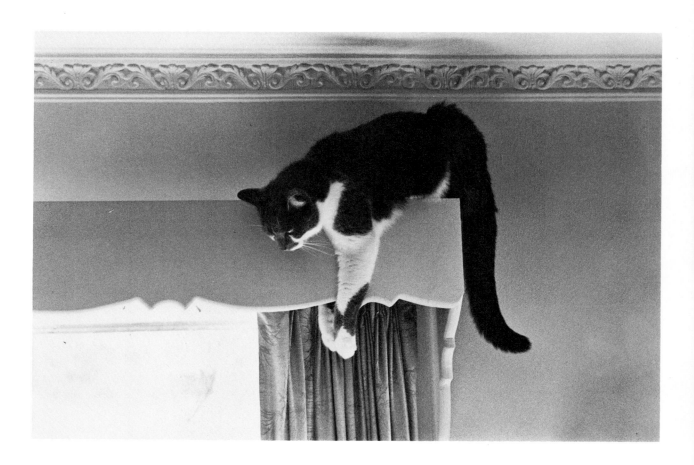

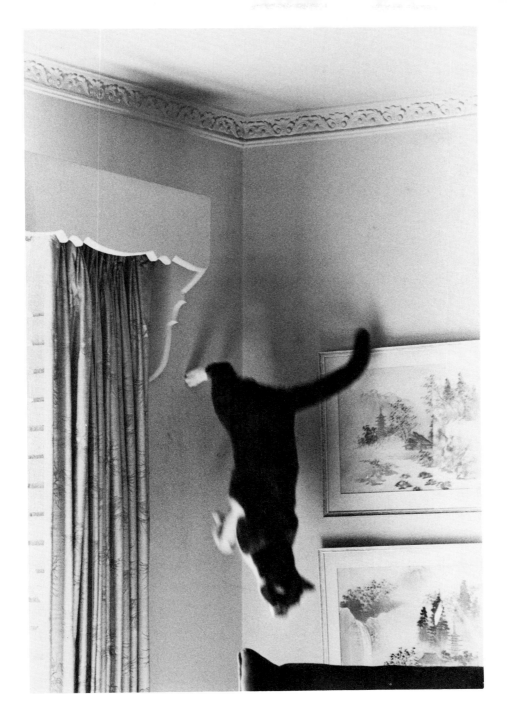

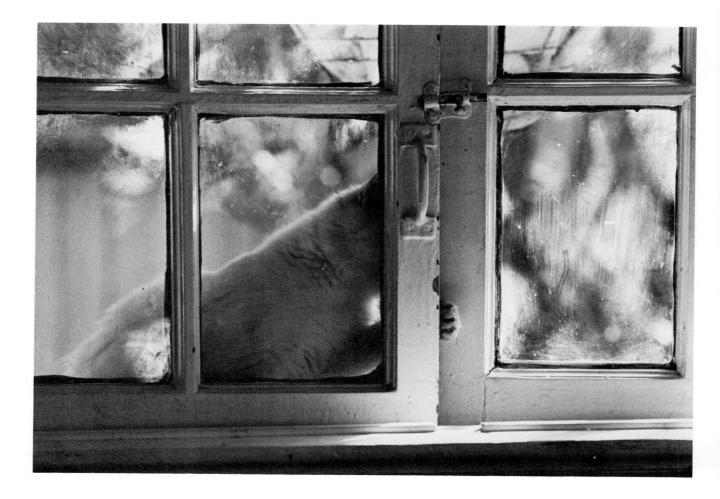

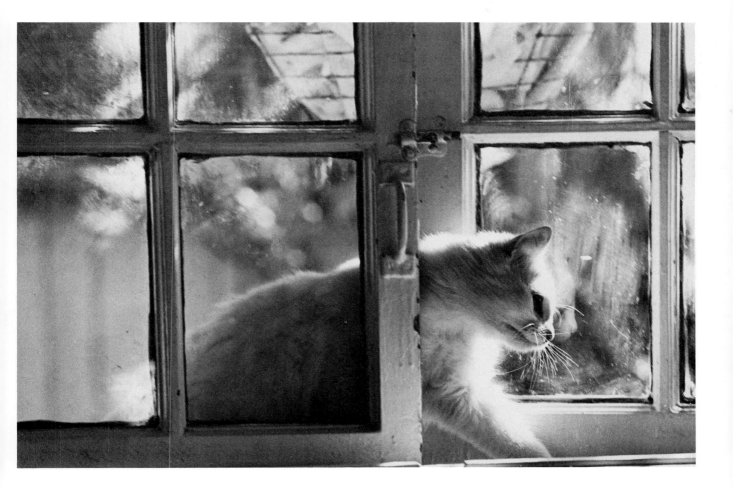

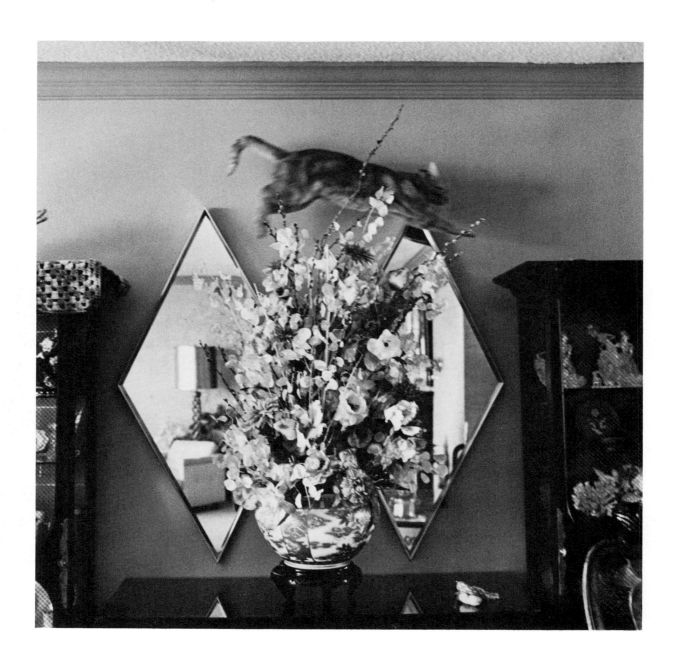

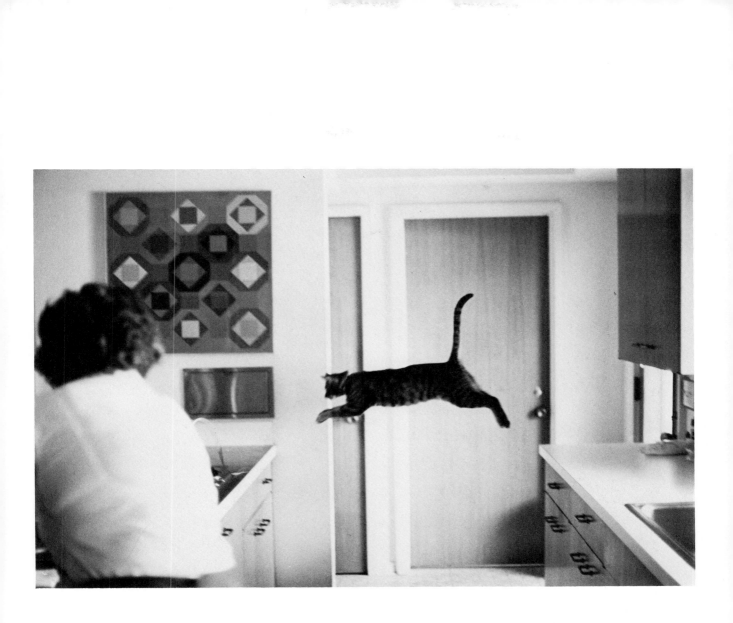

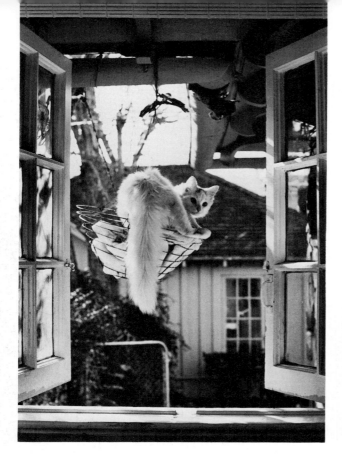
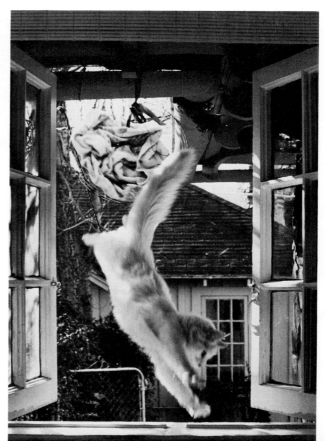

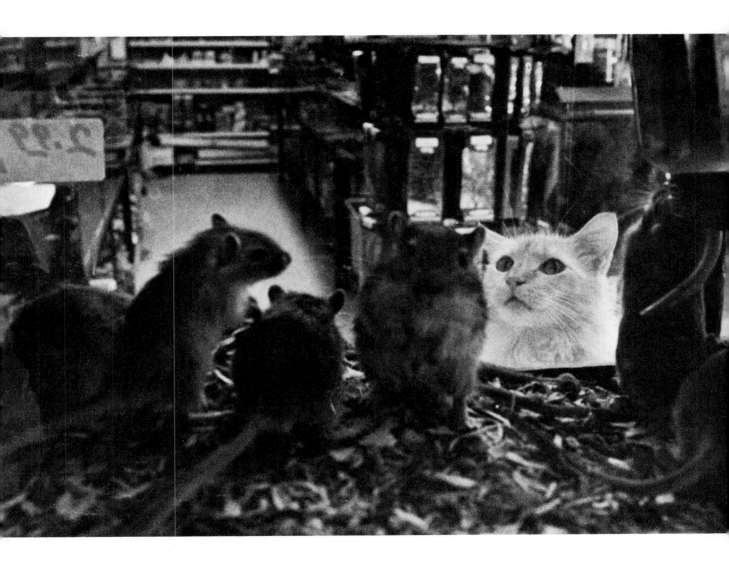

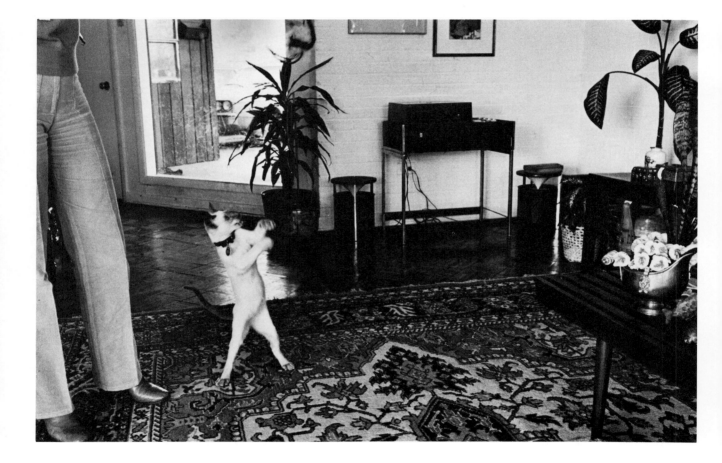

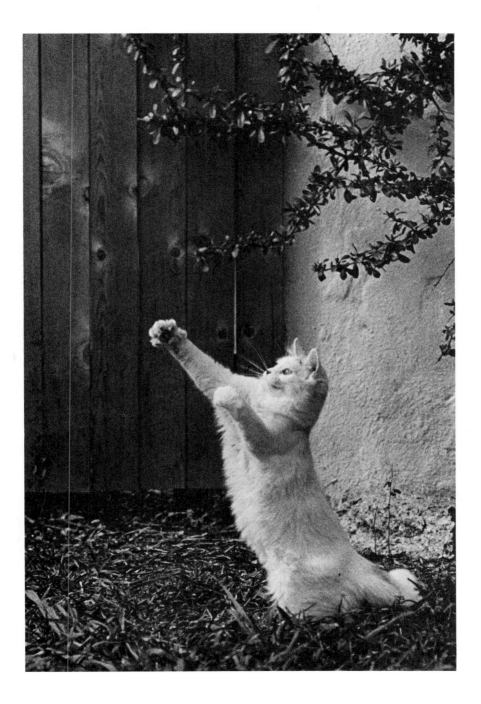

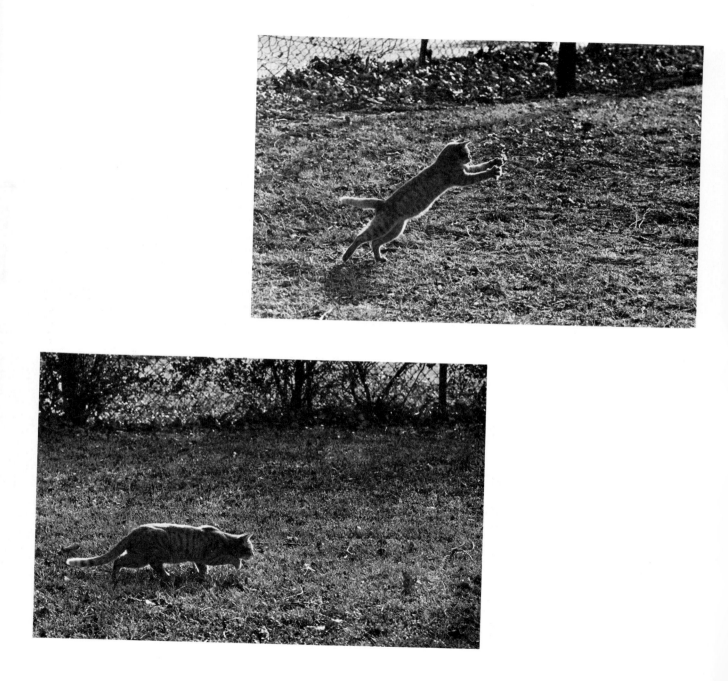

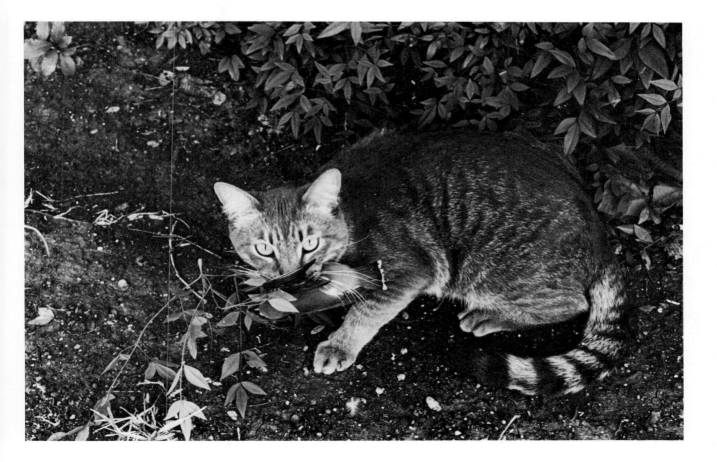

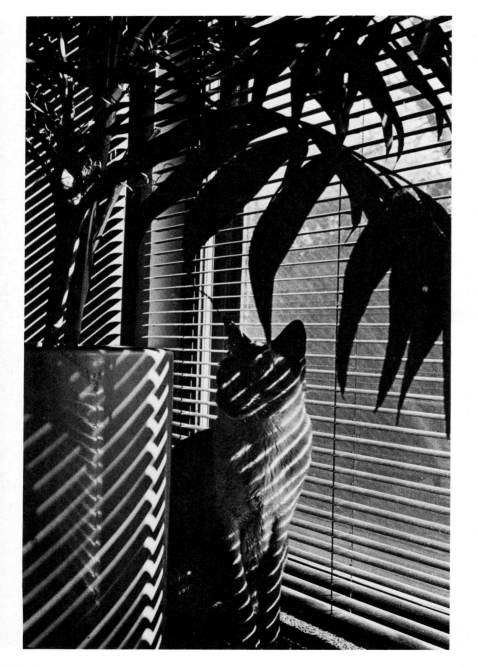

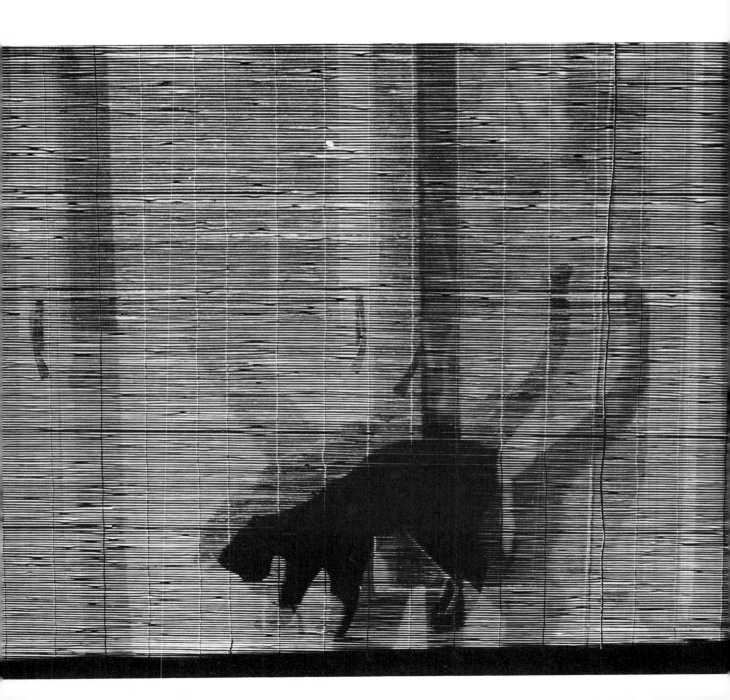

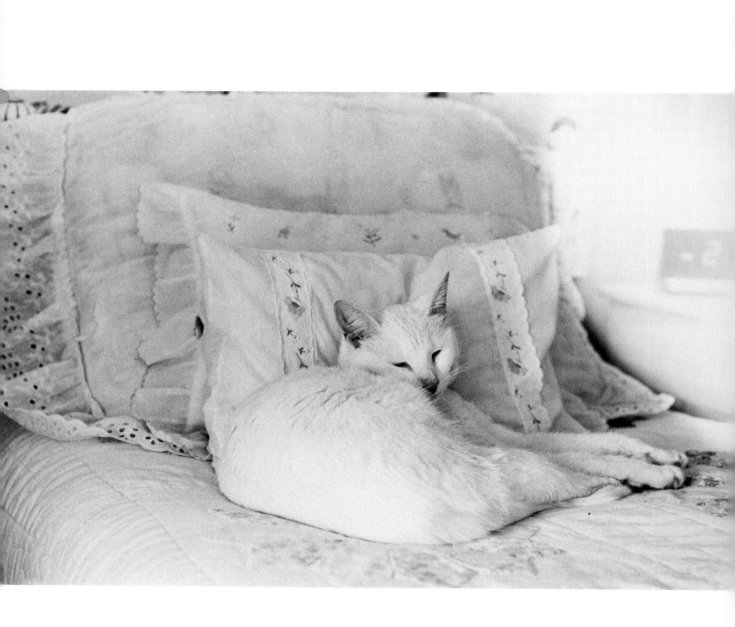

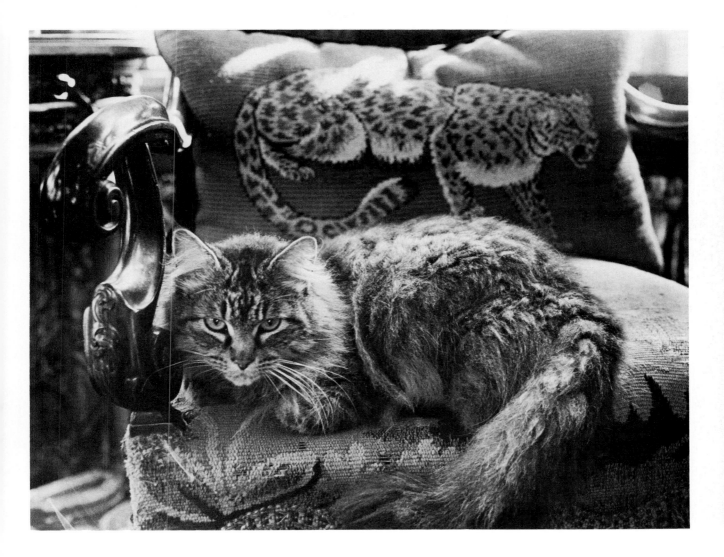

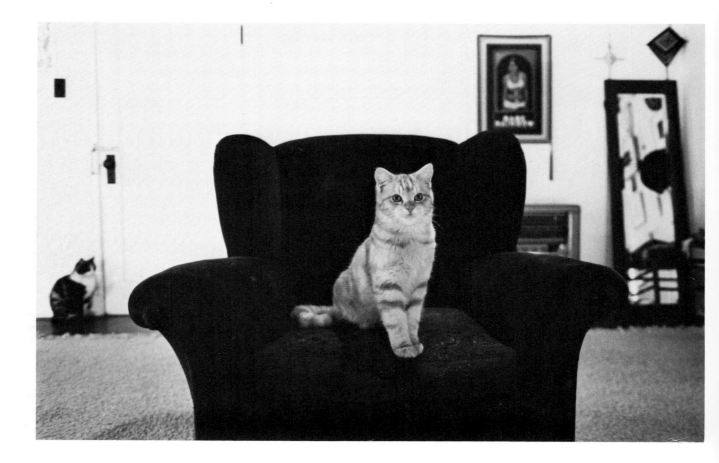

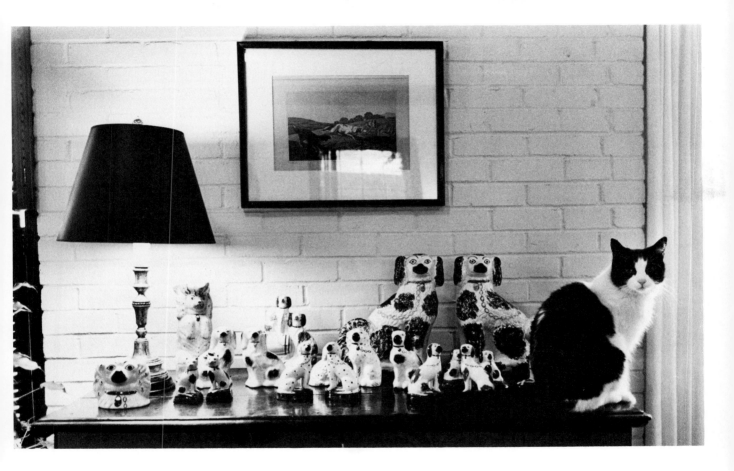

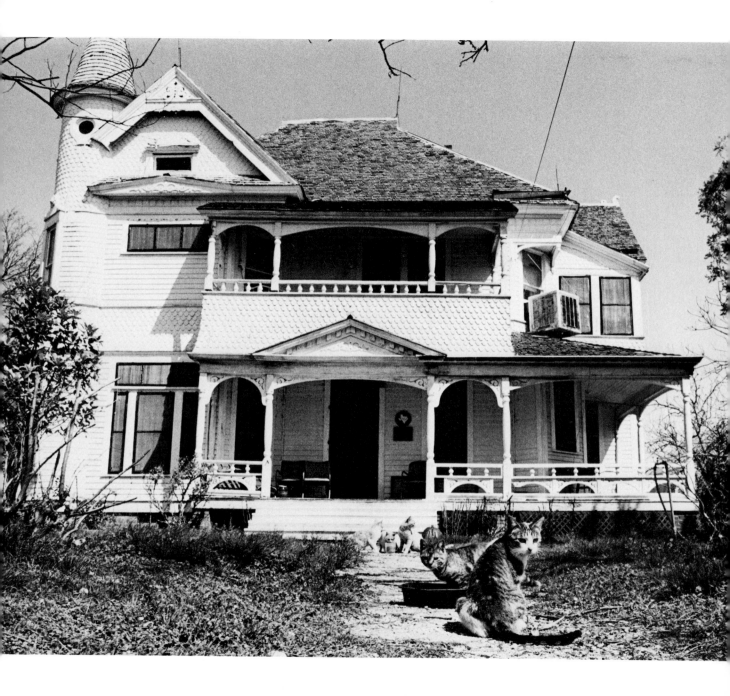

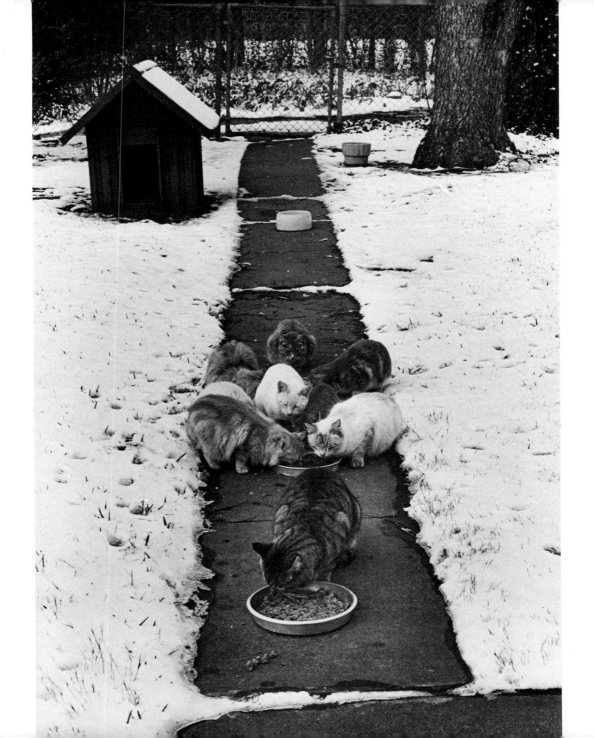

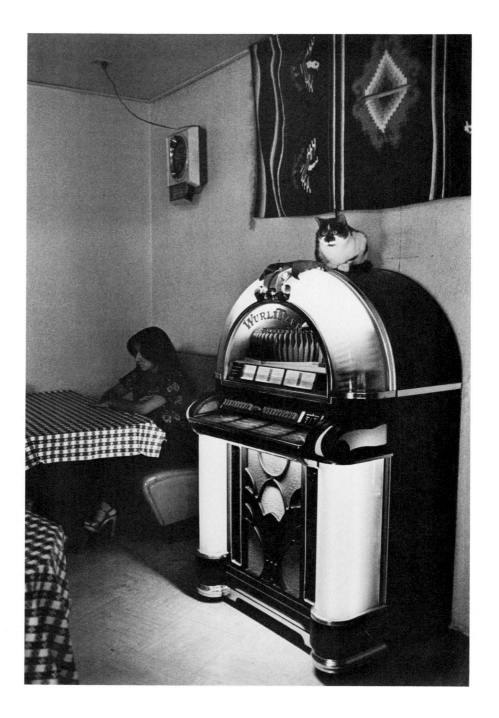

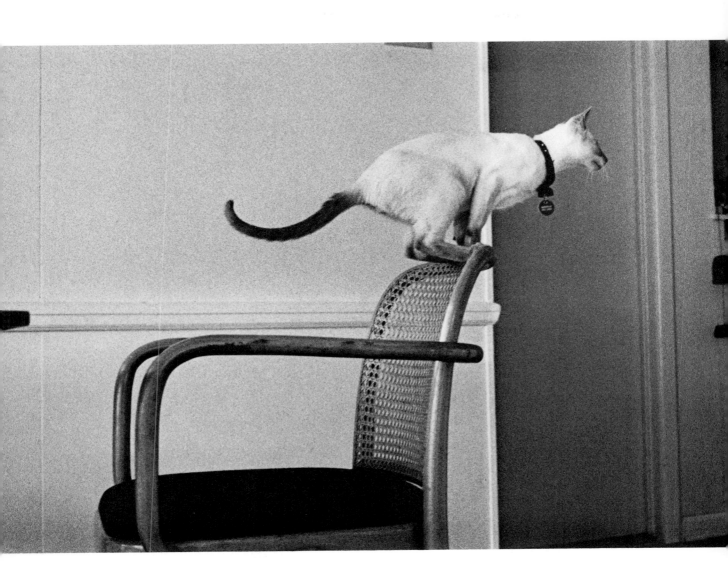

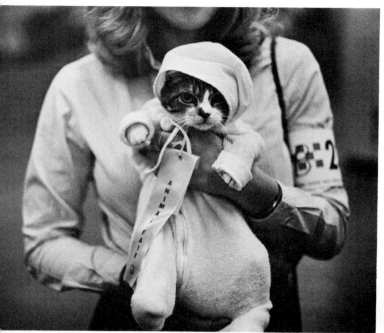

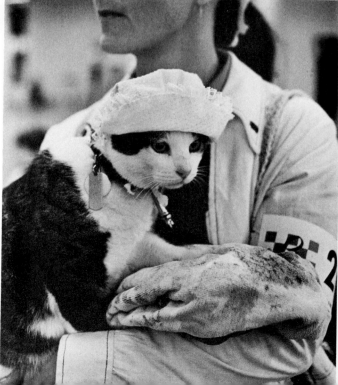

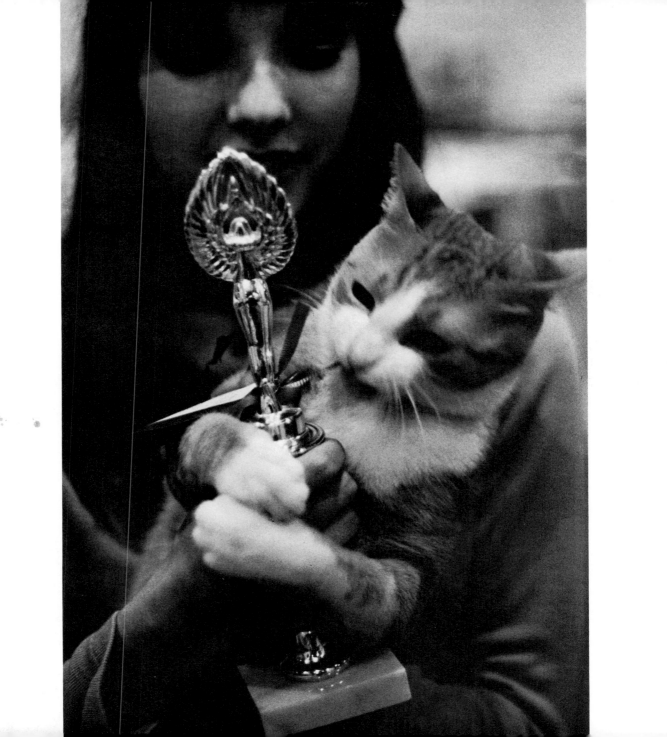

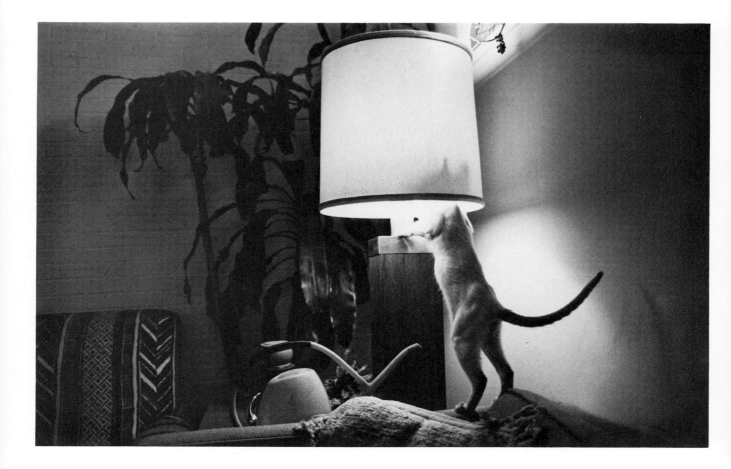

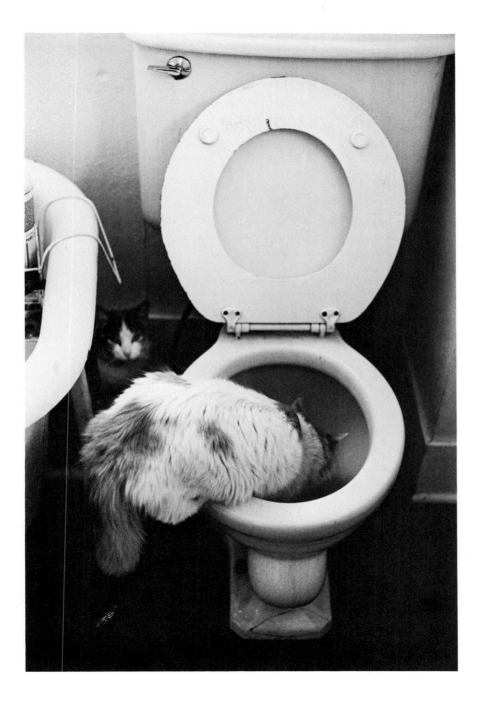

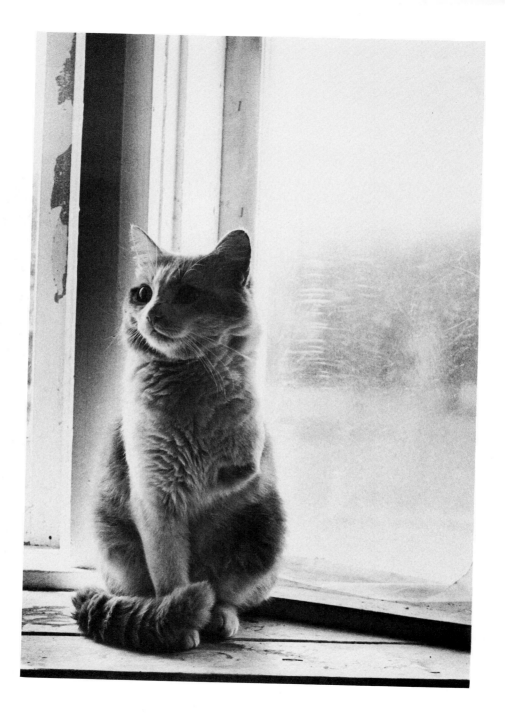

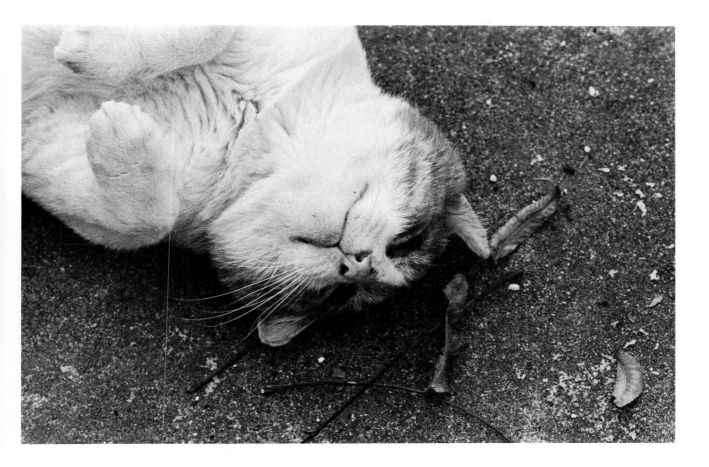

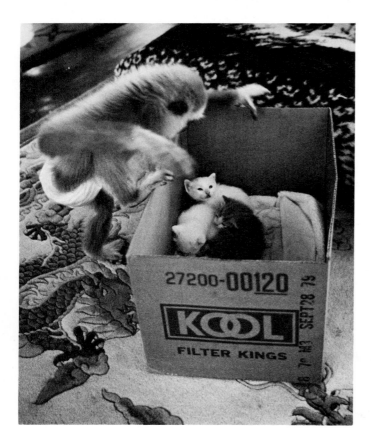

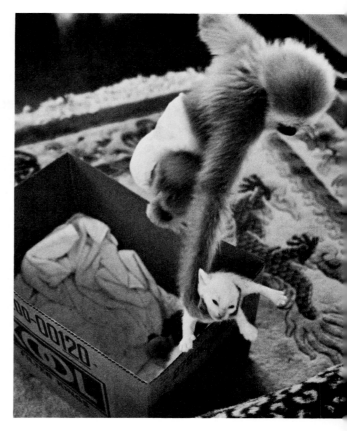

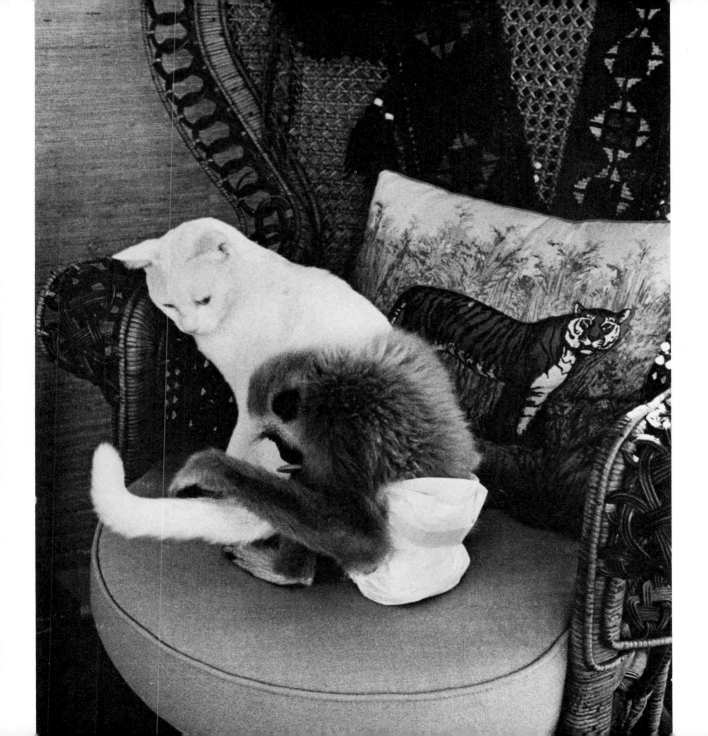

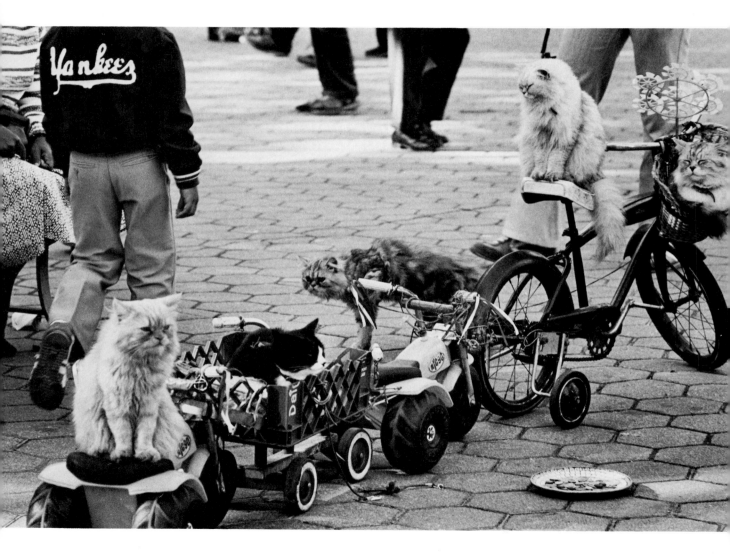

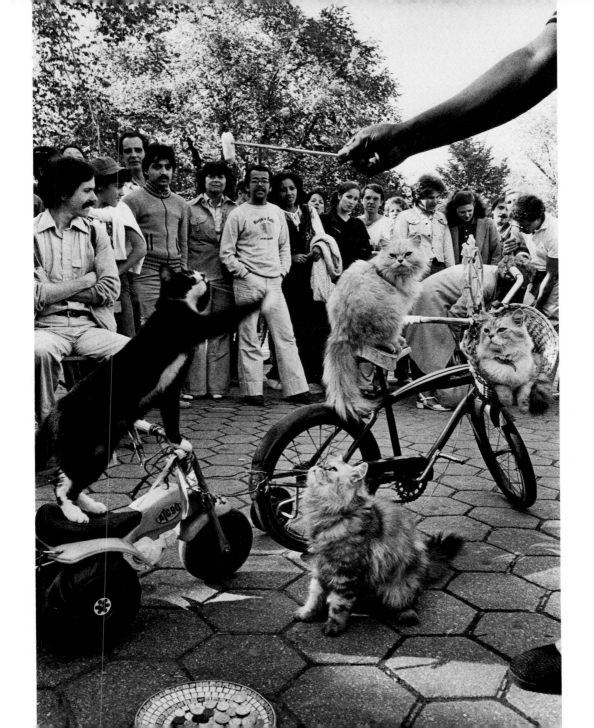

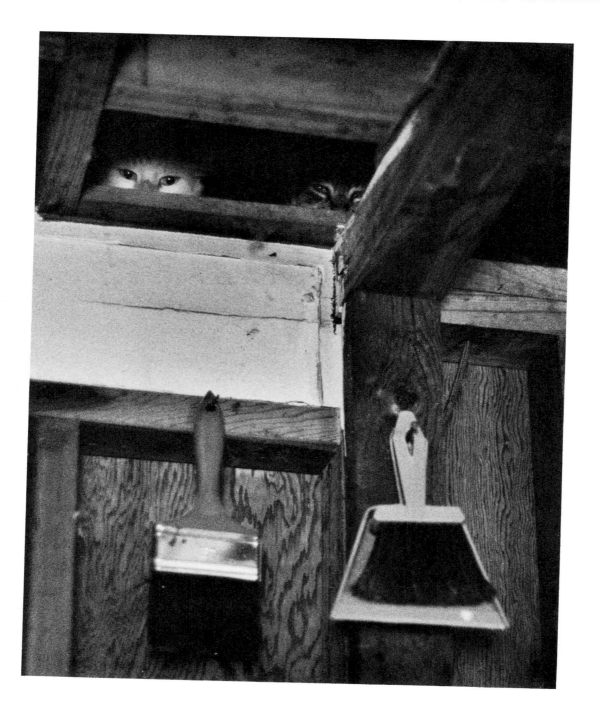

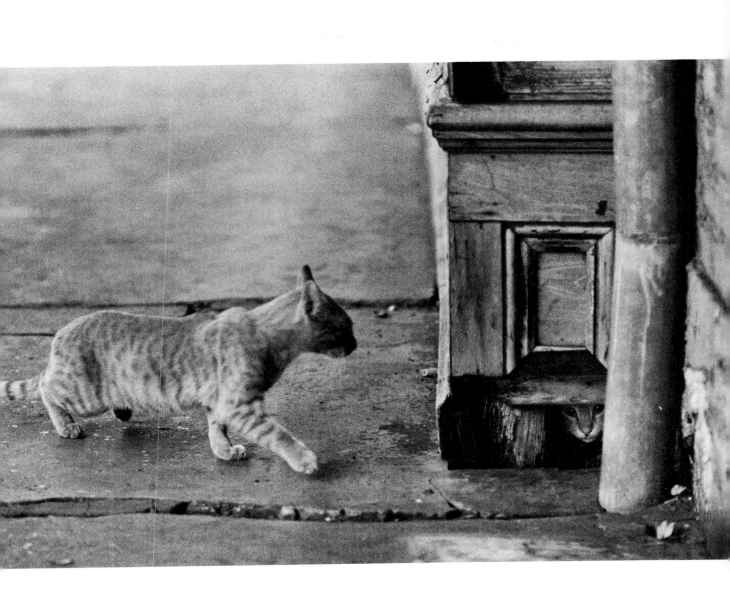

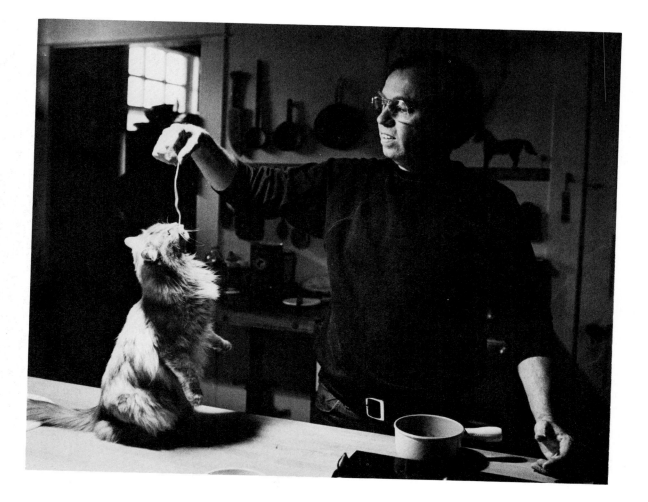

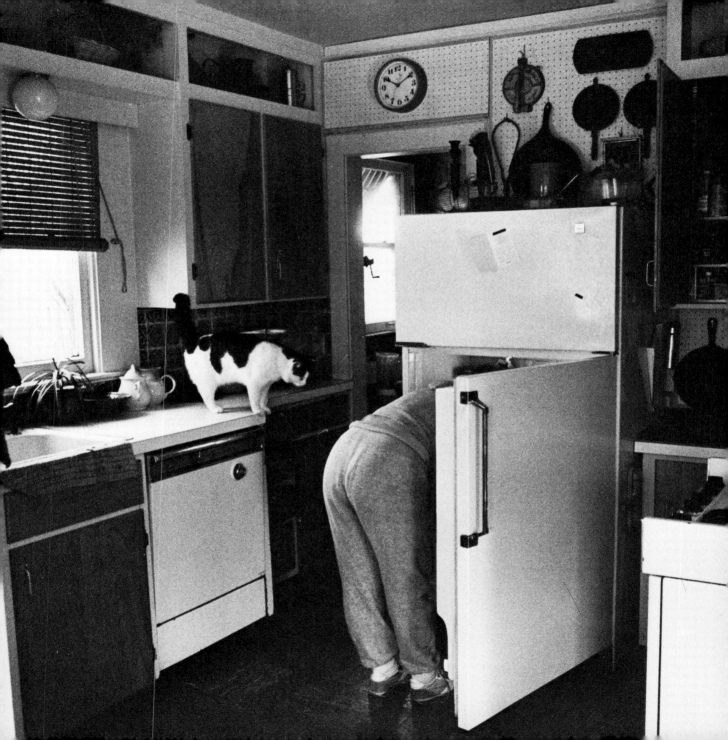

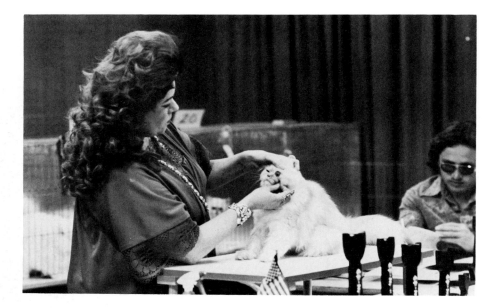
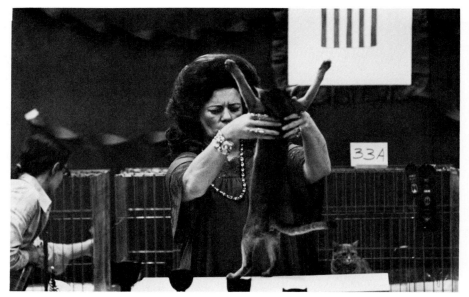

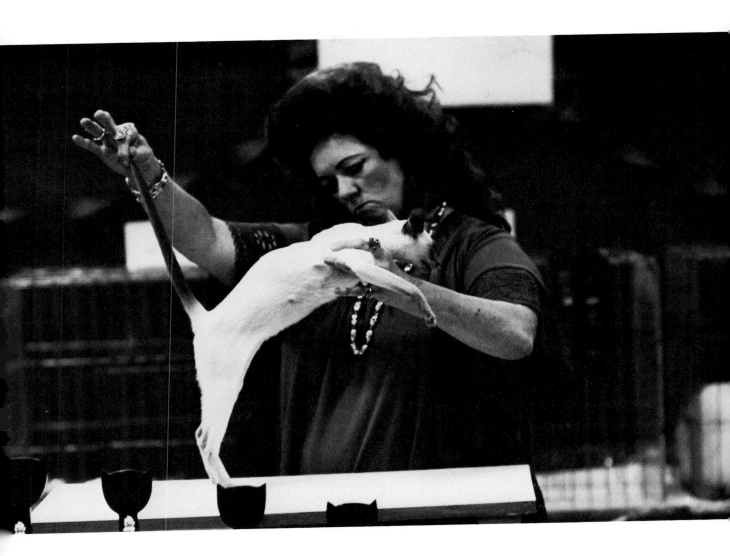

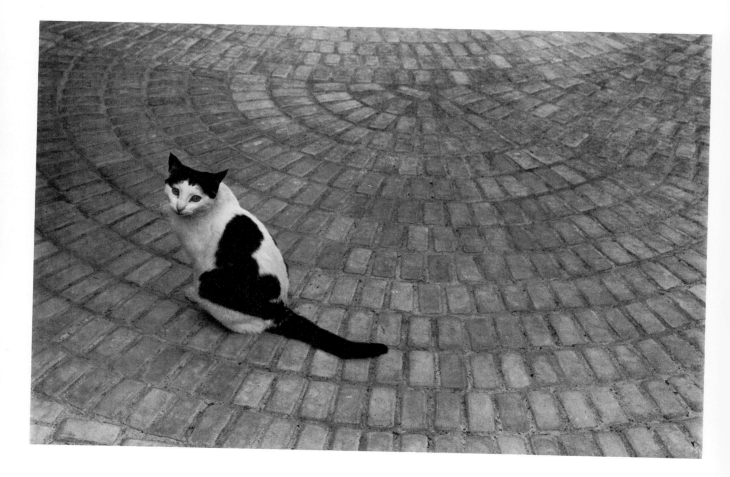

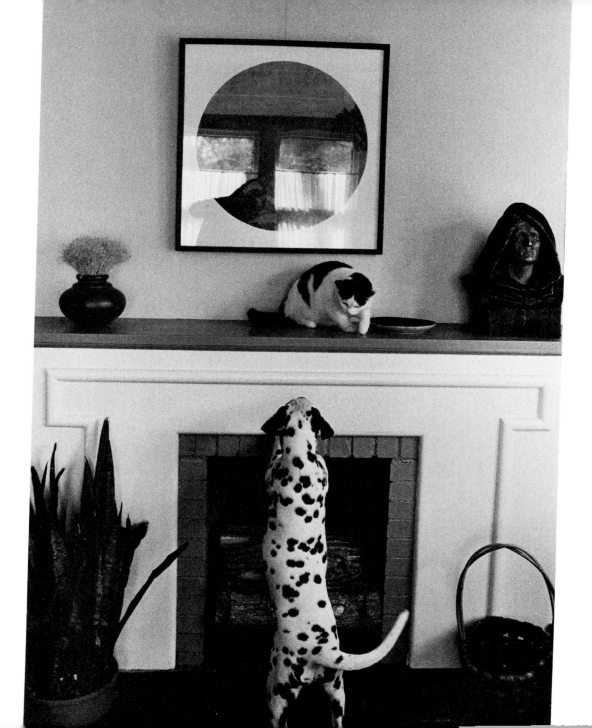

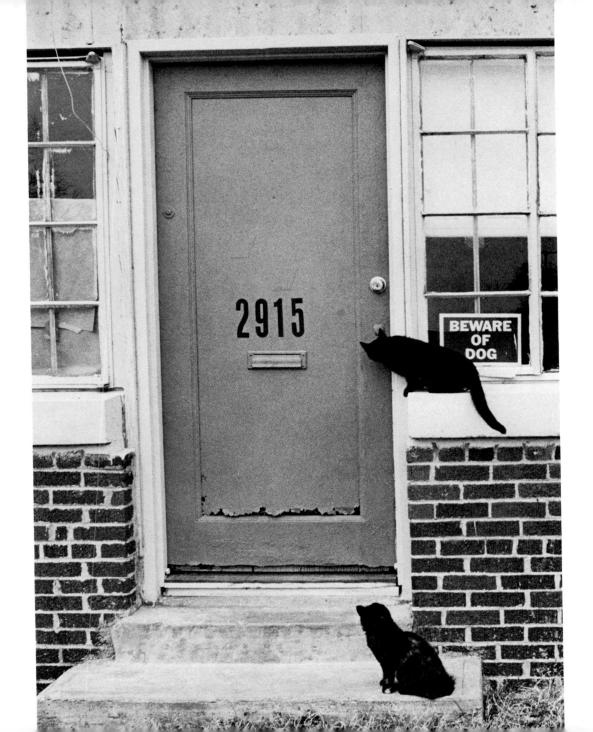

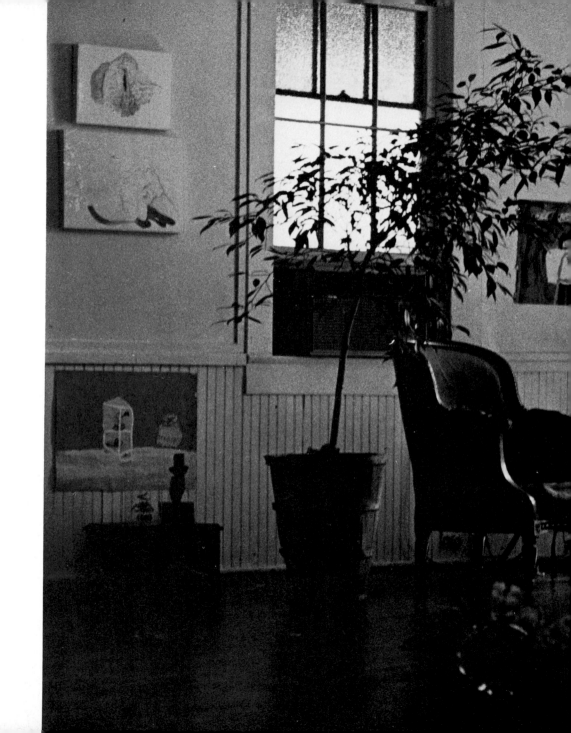

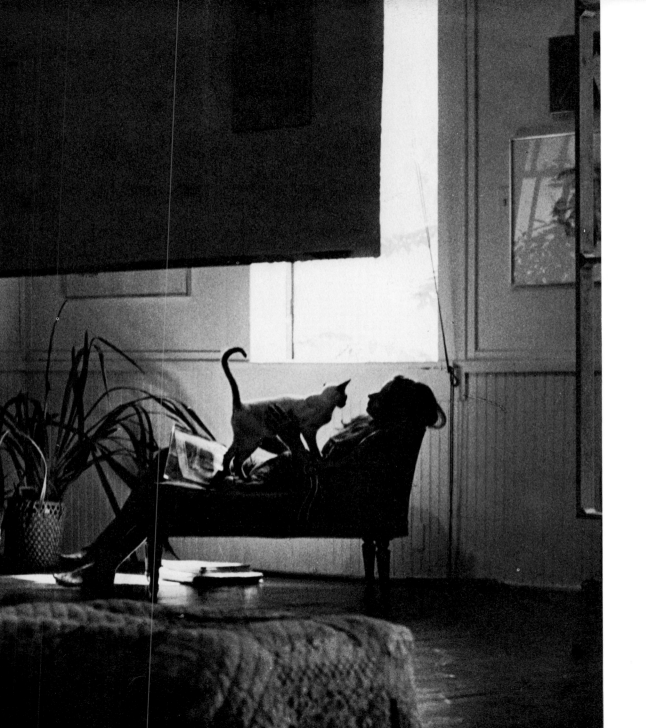

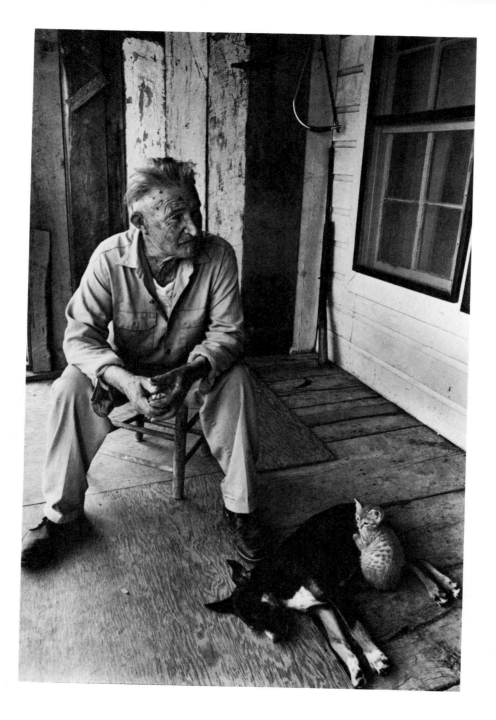

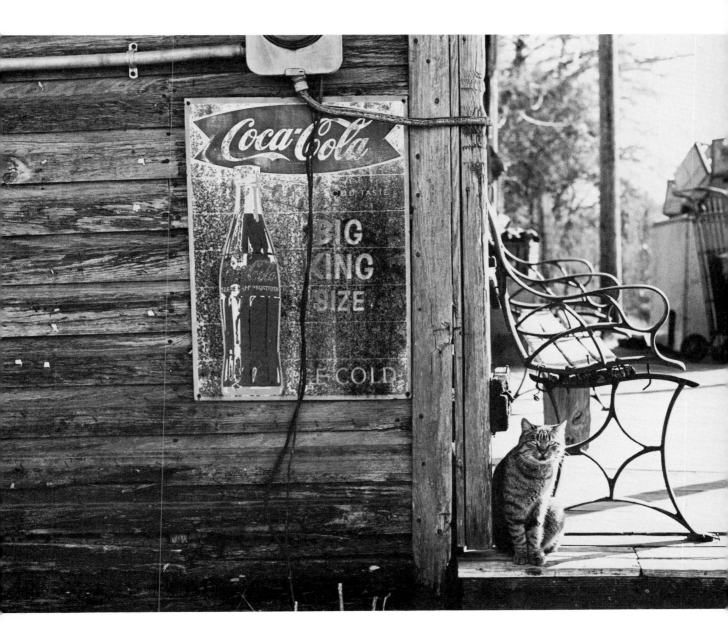

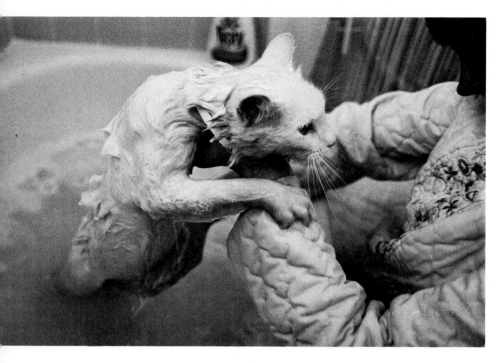

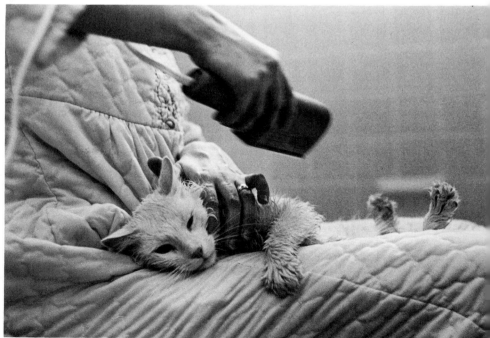

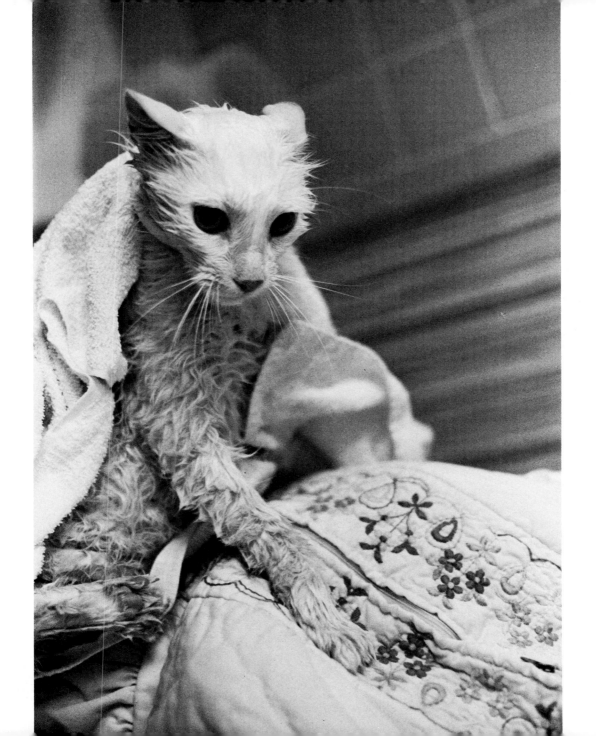

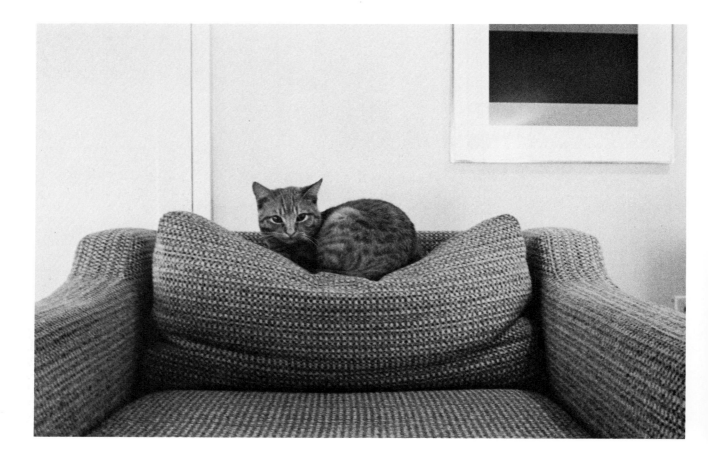

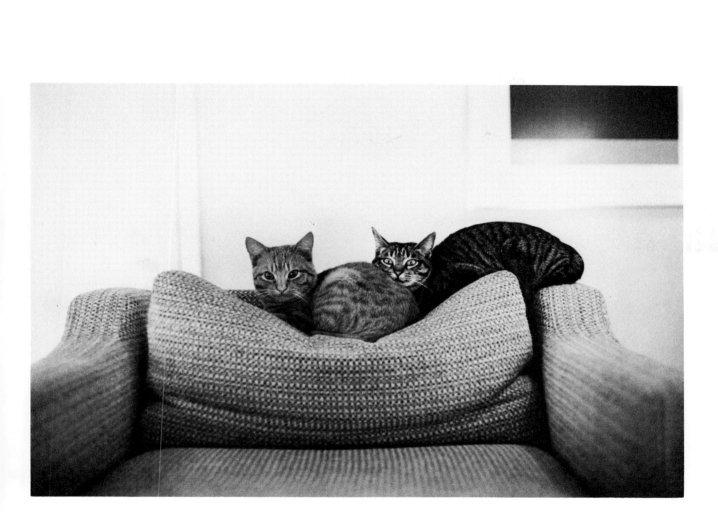

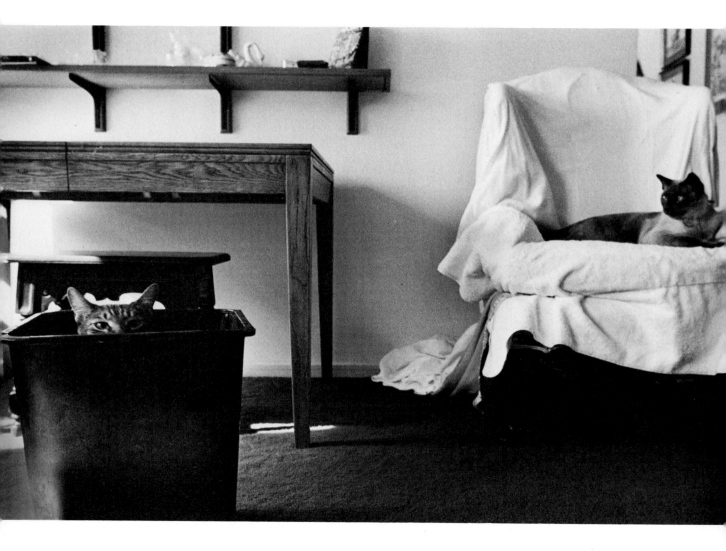

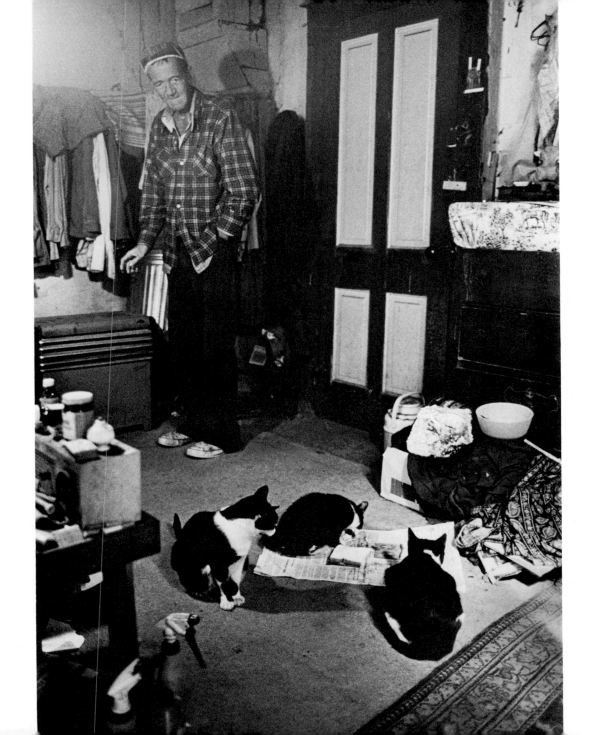

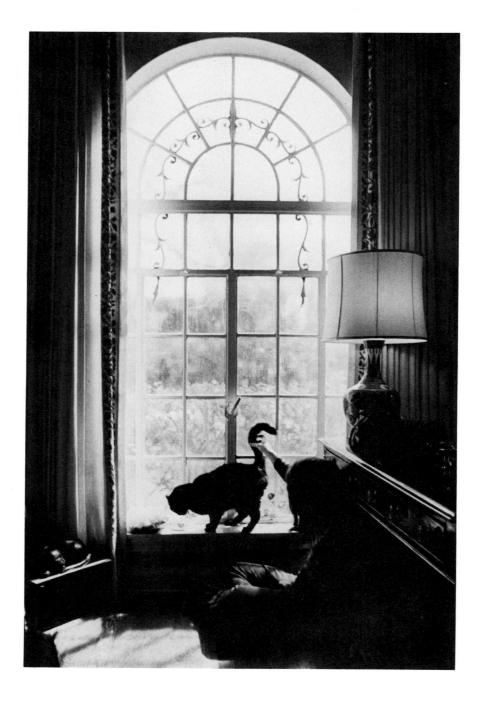

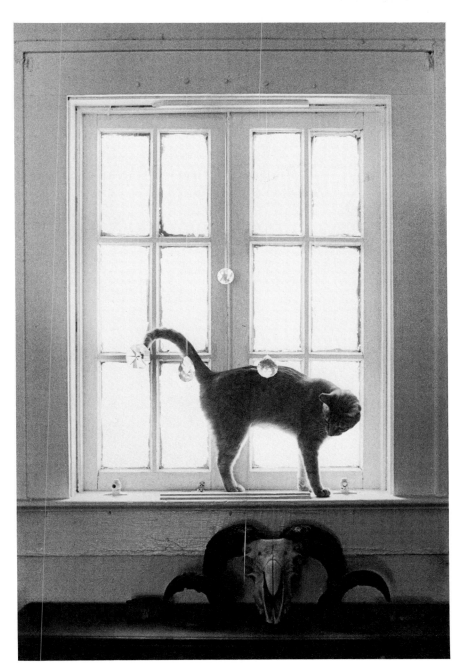

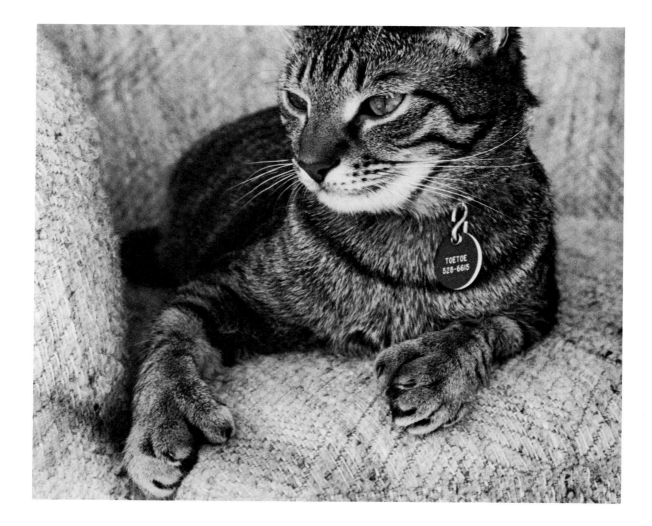

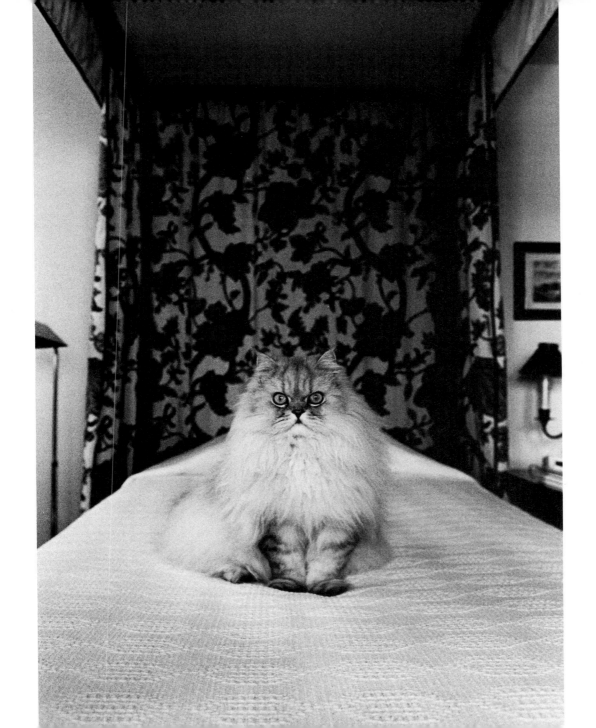

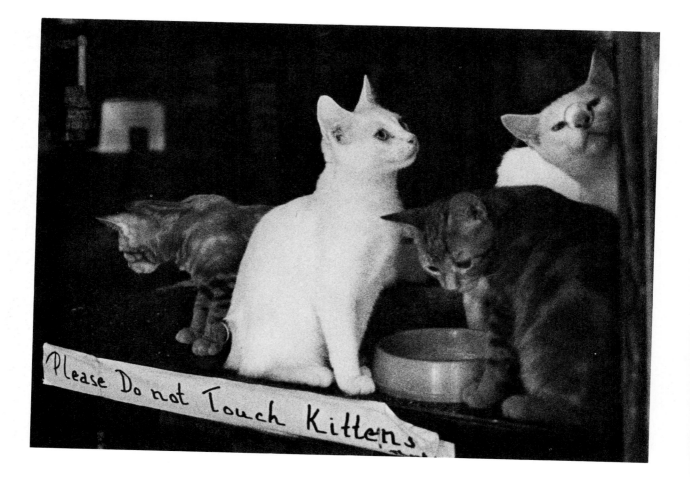

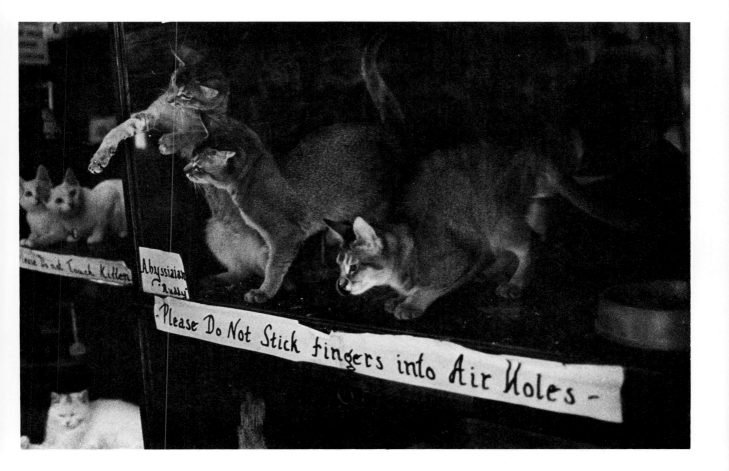

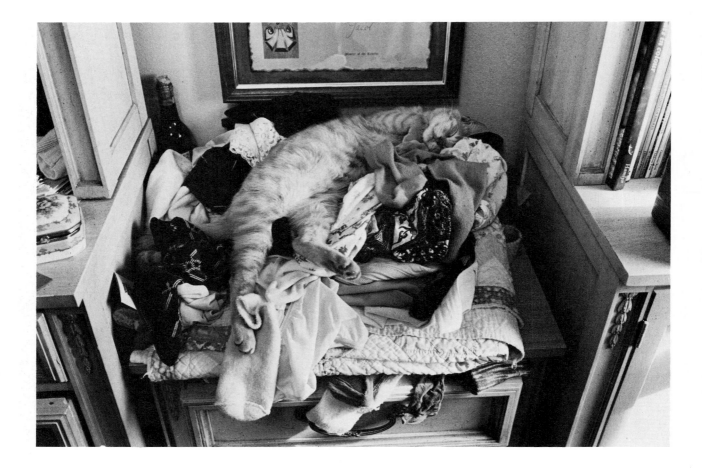

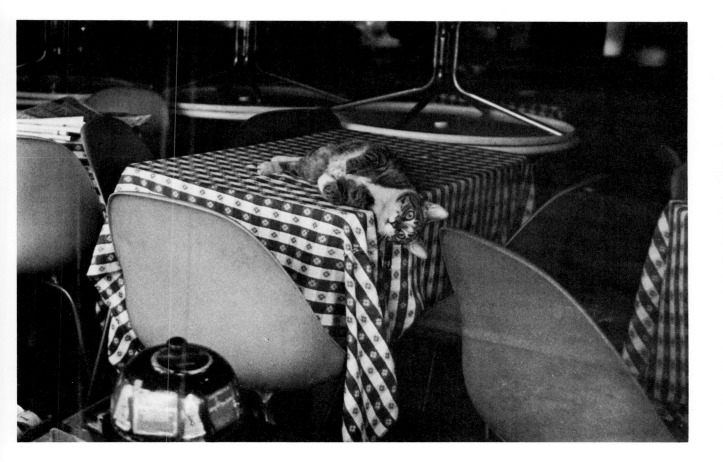

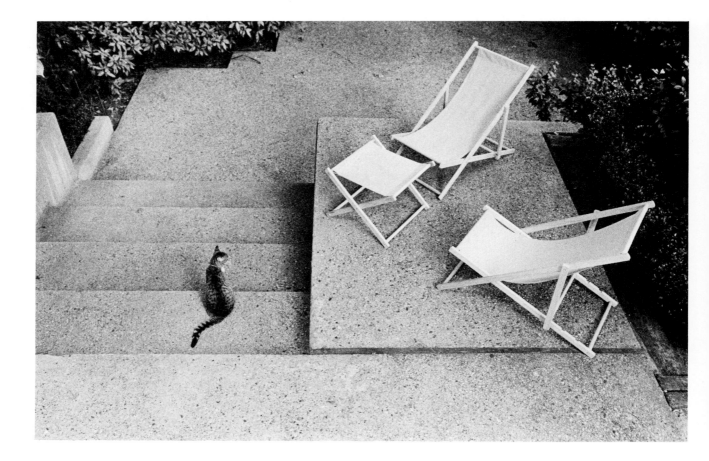

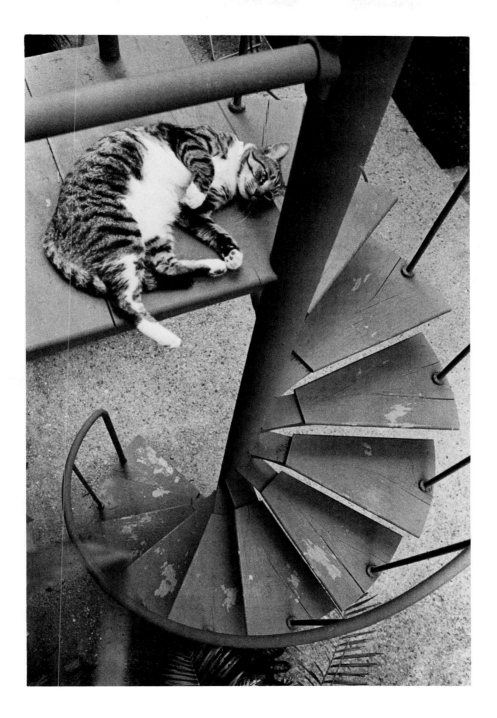

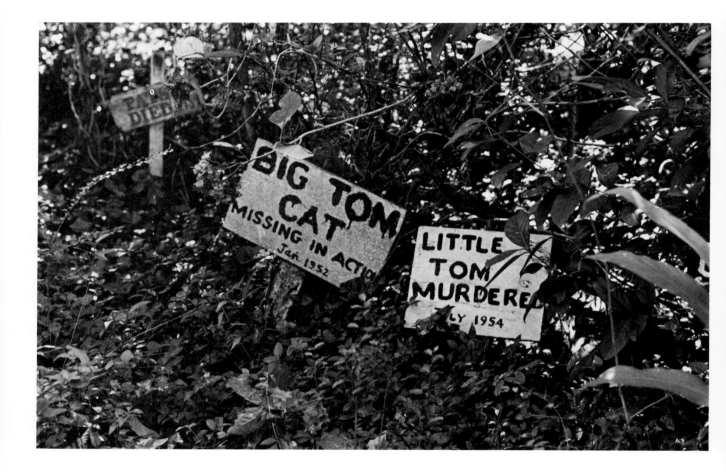

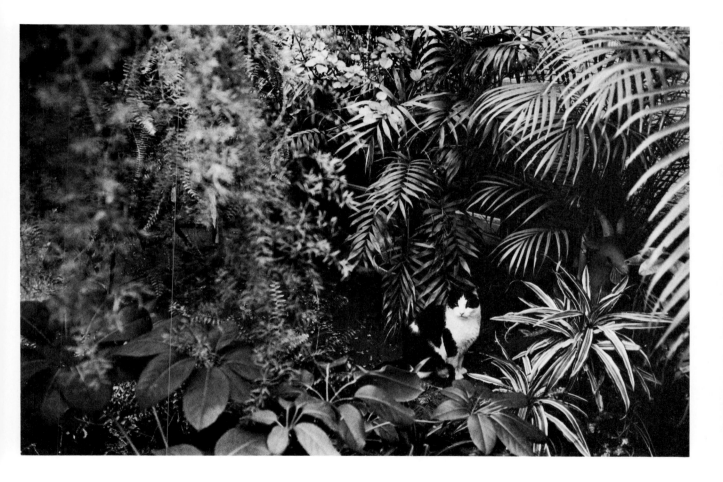

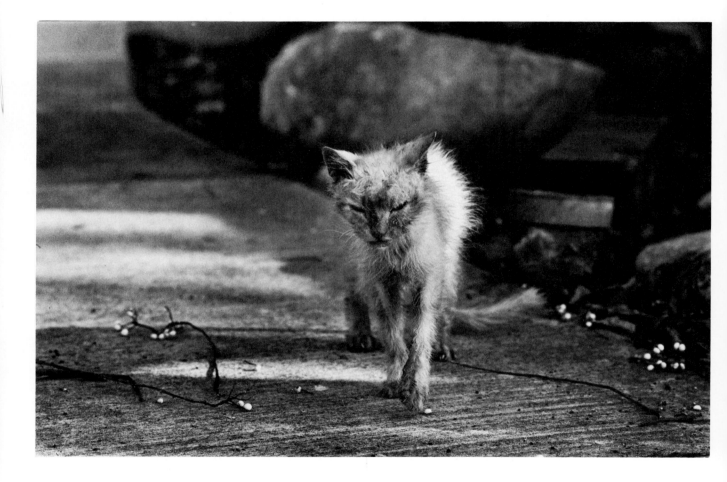

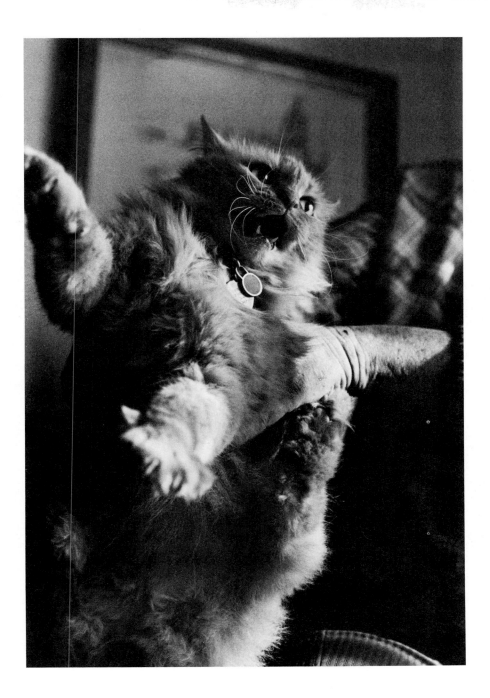

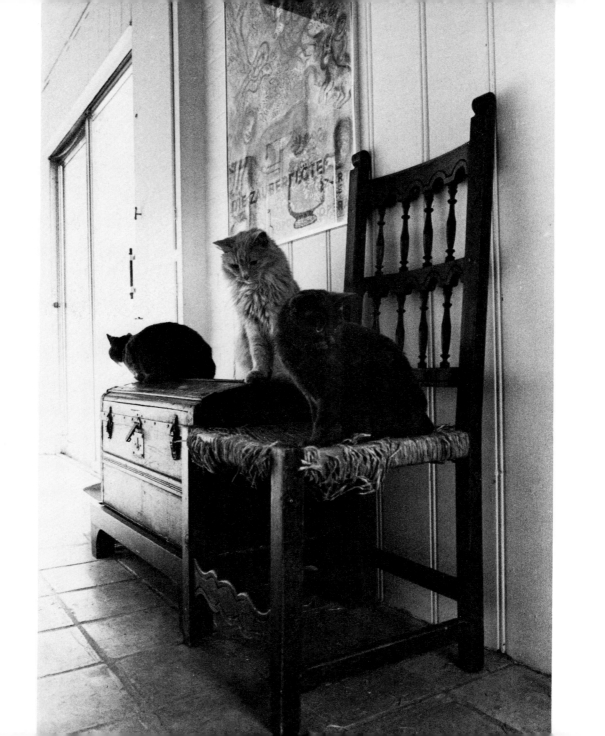

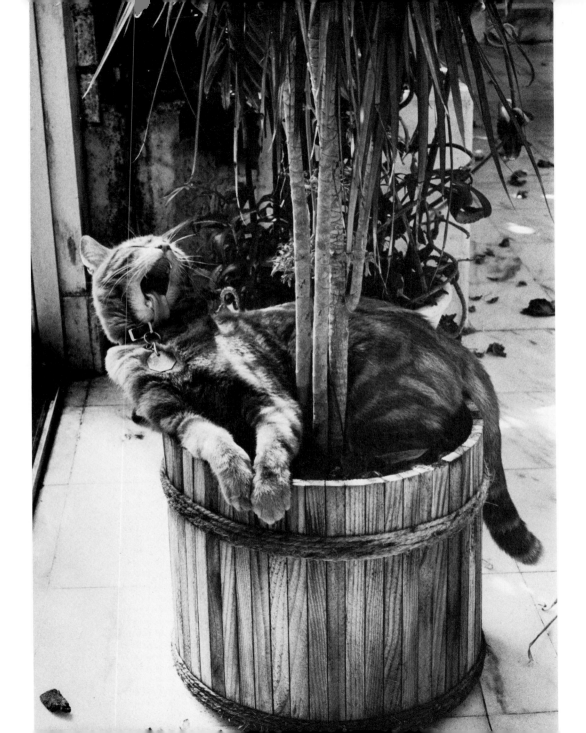

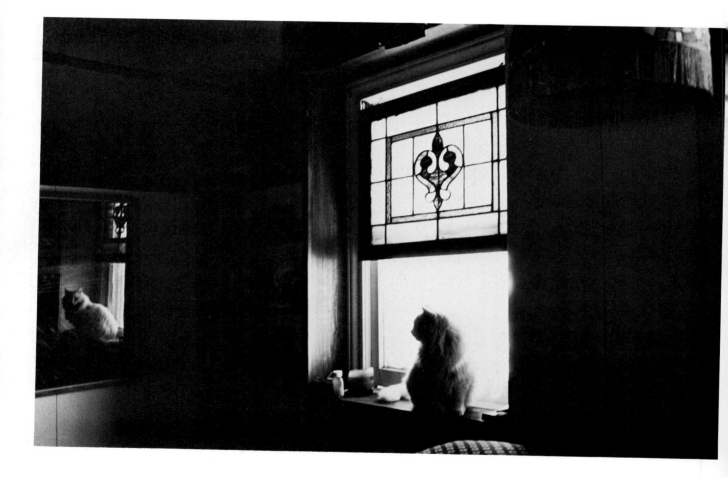

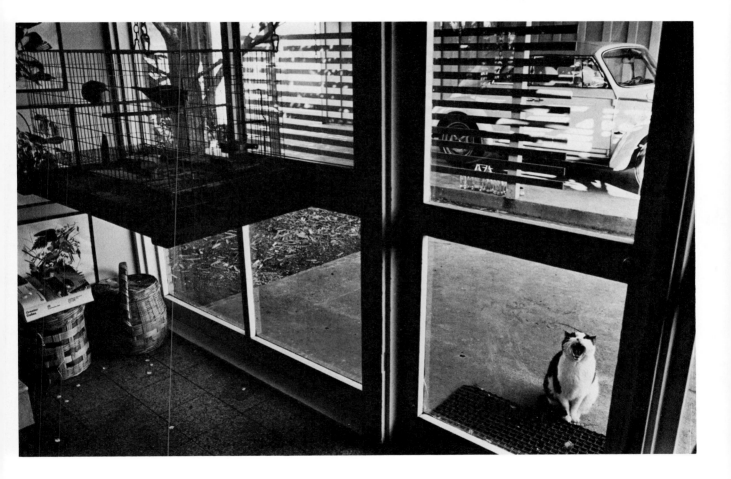

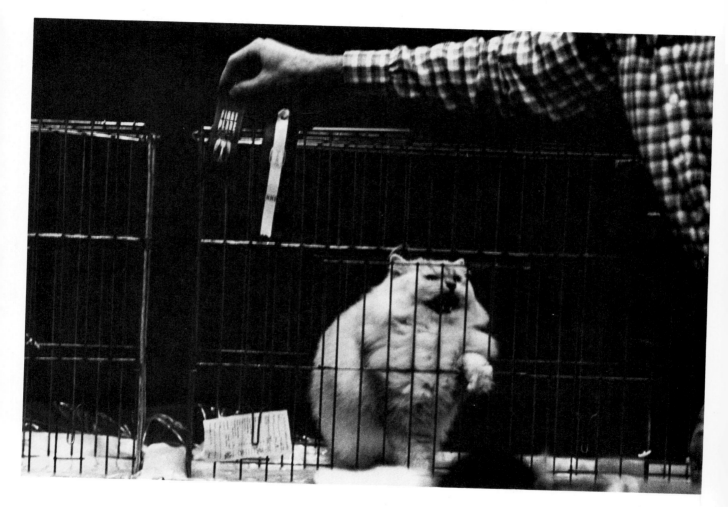

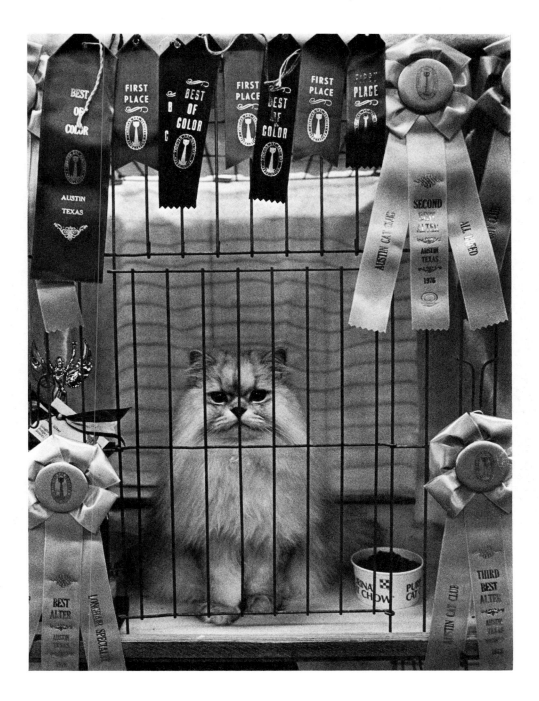

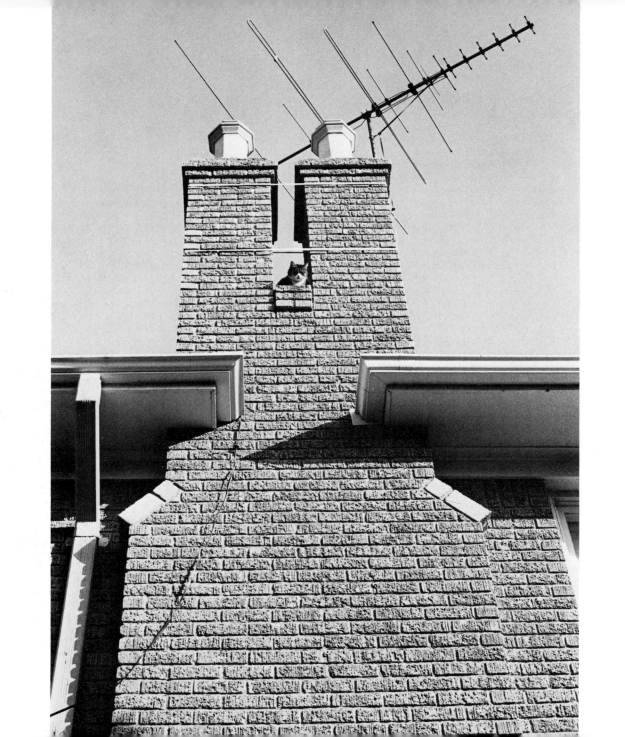

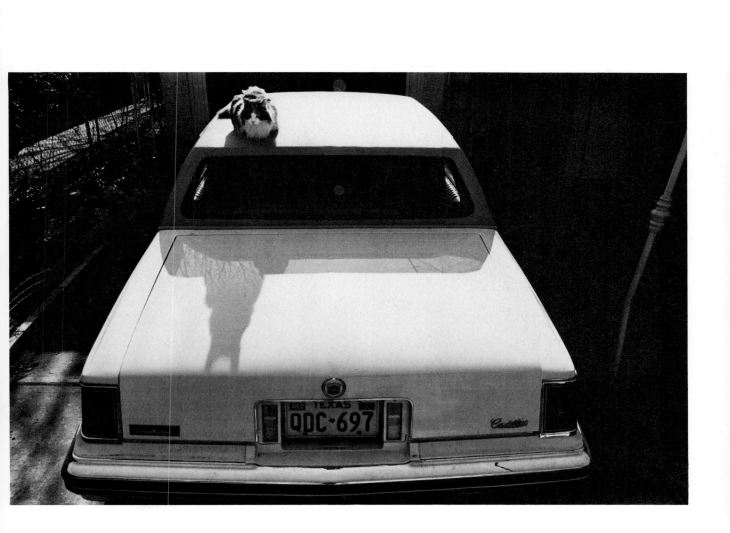

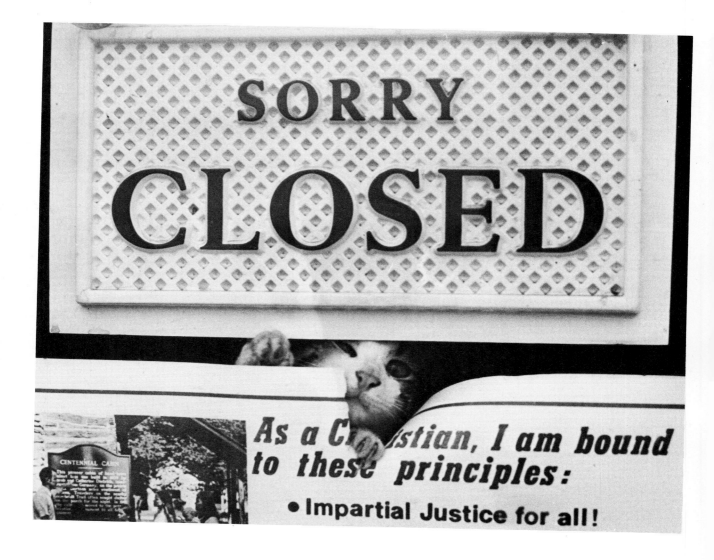

SORRY CLOSED

As a Christian, I am bound to these principles:
• Impartial Justice for all!

CENTENNIAL CABIN